St. Andrews

BY ~ THE ~ SEA

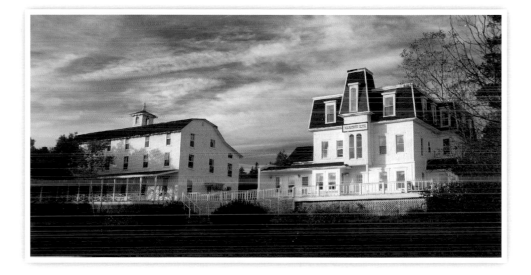

Rob Roy

NIMBUS
PUBLISHING

Nimbus Publishing Limited
PO Box 9166, Halifax, NS B3K 5M8
(902) 455-4286 www.nimbus.ns.ca

Printed and bound in China

Design: Troy Cole—Envision Graphic Design
Author photo: Irina Roy
Photos on pages 1, 32-33, 34, 35 are courtesy of
the Fairmont Algonquin Hotel

Library and Archives Canada Cataloguing in Publication

Roy, Rob, 1953- St. Andrews By-the-Sea / Rob Roy.
ISBN 978-1-55109-656-8
1. Saint Andrews (N.B.)—History. 2. Saint Andrews (N.B.—
Pictorial works. I. Title.

FC2499.S35R69 2008 971.5'33 C2007-907146-5

 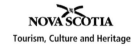

We acknowledge the financial support of the Government of Canada through the Book Publishing Industry Development Program (BPIDP) and the Canada Council, and of the Province of Nova Scotia through the Department of Tourism, Culture and Heritage for our publishing activities.

FRONT COVER: The Algonquin Hotel (1889) was taken over by Canadian Pacific Railway (CPR) in 1902. After a devastating fire in 1914 it was rebuilt the following year using poured cement. It remained a CPR hotel for many years and today it is known as the Fairmont Algonquin Hotel.

TITLE PAGE: The Marathon Inn (1871) was built by ship captain James Pettes as a hotel, and, in 1898, the old Marble Ridge Inn was moved beside it as an addition. Both of these buildings command a spectacular view of North Head Harbour.

BACK COVER: Pedestrians can pass along King Street to the corner of Water Street, as depicted in this mural painted by Geoff Slater of St. Andrews.

Introduction

Seen from Robbinston, Maine, across the broad estuary of the St. Croix River, St. Andrews resembles a textbook image of a Greek colonial city: a cluster of neat, white-painted buildings rising gently toward a citadel, in this case a grand, château-like hotel. Like Greek cities, St. Andrews was settled from the water. Loyalists on the eastern seaboard, who were on the losing side in the Revolutionary War, sought refuge in the remaining British territories in North America. To ease their flight an indebted British government provided transport, supplies, building materials, town plans, and the military surveyors to implement them. Fortunately, the St. Andrews Loyalists had the benefit of hindsight, as they were the last contingent to leave for the Maritimes. Determined not to repeat the mistakes of Shelburne and Saint John, streets, squares, and building lots were laid out before their arrival

and the lots were drawn in the port of embarkation, Castine, Maine. There was still bargaining for choice commercial lots but initially the settlers went peaceably to the ones they had drawn.

For the plan of their townsite the Loyalists, like colonizing groups from the Greeks onward, followed a simple rectangular layout of straight streets and square blocks. The ideal townsite, as planned by the London-based Board of Trade and Colonization, was south-facing and, for drainage purposes, gently sloping. In coastal towns there was typically a market square in the centre of the waterfront and, back from the water, squares for courthouses, schools, and hospitals—in St. Andrews the directives were carried out to the letter. Straight streets paralleled the shore while others ran gently upslope at right angles. As tokens of their loyalty,

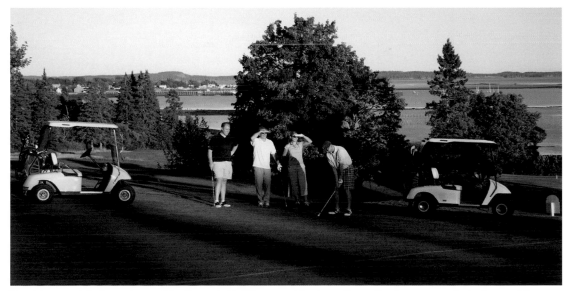

The plateaus and sloping contours of the Algonquin Golf Course and Academy allow golfers to gaze upon the harbour and the town's waterfront as the game proceeds.

but also as reminders to the British of what that loyalty had cost, the street names had royal associations. King, Queen, Princess Royal, and Prince of Wales need no explanation but most of the others were named after the thirteen royal children, beginning with Adolphus and ending with William. Only Carleton and Parr, named after prominent military and political figures, and Water, the street closest to the shore, escaped royal designation.

As the town developed, the houses and public buildings began to complement the strict symmetry of the streets. The first houses were makeshift, made from materials supplied by the British or from numbered pieces of dismantled buildings shipped by scow from Castine. Once established, however, the merchant and professional classes built substantial two-storey townhouses in the Georgian or neoclassical style then fashionable along the eastern seaboard. Its hallmarks were compact, rectangular shapes and balanced

façades: a central doorway, usually with transom and sidelights in the grander houses, and well-proportioned windows arranged symmetrically on either side of the front door. Clapboard was generally the material of choice for the exterior, but occasionally more expensive brick was used as well. Interiors were just as standard as exteriors. The layout of each floor included a pair of rooms of roughly equal size on each side of a central hallway and staircase. Late eighteenth- and early nineteenth-century building and planning share the same basic principles.

King Street, wider than the rest and running upslope from Market Square, was the stage for some of the grander houses, the Anglican church, and the Loyalist burial ground. King Street's junction with Montague, two blocks north of Market Square, is the most distinguished street intersection in Canada, according to one historian of architecture. There are houses in the

Green's Point Museum and Interpretive Centre is located at the very site of the 1903 Green's Point Lighthouse.

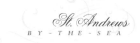

Georgian or neoclassical style on three corners and a handsome church set in greensward on the fourth.

St. Andrews prospered for approximately forty years after its founding. It was the county town and, due to its strategic position along the international border, also a garrison for British soldiers. As a colony, its merchants enjoyed favourable trading arrangements with Britain and the British West Indies—both needed lumber, ships, naval stores, and, in the case of the latter, dried fish. Goods that St. Andrews and Passamaquoddy Bay were unable to provide were bought from American suppliers then carried to their final destination in Maritime ships. As carriers, St. Andrews merchants prospered, notably in times of hostility between Britain and the United States as the warring parties could not trade directly yet needed the goods of the other. British manufactures, on one side, and American raw materials on the other, were shuffled across "the lines," the indeterminate international waters that neither side could really claim, to awaiting American and British vessels.

But a prosperity dependent upon protected markets and continued friction between Britain and the United States was clearly precarious. Once tempers cooled and Britain embraced free trade, St. Andrews' fortunes tumbled. American vessels as well as American goods took over the West Indian trade and Scandinavian lumbermen gained ingress to the British market because there were no tariff barriers to scale. With the sea no longer the lucrative avenue it had been, St. Andrews, which has no hinterland, found itself stranded at the end of a long peninsula. A bold and imaginative scheme to make it the winter port of Canada by building a railway line from ice-free Passamaquoddy Bay to Quebec City foundered when the United States learned that the prospective line was to run through disputed territory that is now northern Maine. People drifted away from St. Andrews and by 1880 the population had fallen to its current level, fewer than two thousand, about half to two-thirds of the estimated population around 1800.

Kandy Land's Loyalist cut-out figure provides fun for visitors as they stroll by the merchant stores on Water Street.

The few observers who passed through consigned the town to oblivion, one describing it as the most somnolent place he had ever set foot in, the main street deathly quiet and the harbour empty except for a few abandoned hulks. Yet the town survived. The currents of the Atlantic trade may have bypassed Passamaquoddy, but a beautiful harbour cooled by the Bay of Fundy's huge tidal exchanges and within a day's journey by rail from the great cities of the east was poised to take advantage of one of the growth industries of the late nineteenth century: tourism. Early visitors found the town somewhat the worse for wear but in a remarkable state of preservation, "the ruins of a once lively fishing port now passed into a dream" according to a reporter for the *Boston Home Journal*. Entrepreneurs may shudder at the thought of a decades-long economic depression but conservationists like nothing better.

Climate was just as important to railway tourists as setting. In summer, Montreal and cities along the American seaboard were stifling and unhealthy, and with no antidotes for diseases such as malaria and, in early days, yellow fever, the only remedy was flight. Well-to-do city dwellers headed for the hills and cool coastal places where they would be relatively safe from mosquitoes and the miasmas or airborne poisons that

originated, so it was thought, in hot sultry places. Until Pasteur there was no certain knowledge of the causes of infectious disease. St. Andrews also promised relief from two other afflictions of the urban middle classes: hay fever and neurasthenia, the latter a debilitating nervous disorder. Boarding houses and summer hotels were opened to accommodate summer visitors, but it was the arrival of the Canadian Pacific Railway (CPR) and the railway's builder and president Sir William Van Horne that confirmed St. Andrews' status as a tourist mecca. Van Horne and other CPR executives built large summer houses on choice parts of the shore and on the crest of the slope overlooking the town and the bay. In both locations executives and shareholders in American railroad and steamship companies joined them.

The enormous Fundy tides delivered another lifeline to St. Andrews. Cold, nutrient-rich waters pumped up daily from the sea floor sustain phytoplankton and zooplankton, which are the staple diet of most marine creatures. The eddies and currents concentrate the zooplankton in the waters around St. Andrews to the point that the layers are thick enough to attract not only fish but whales, porpoises, and dolphins. In turn, birds such as gulls, ospreys, sea hawks, cormorants, and bald eagles are drawn to the area to feed on herring and any other species they can kill or carry away. A rich and varied ecosystem on the doorstep of an attractive town with excellent rail connections to Boston and Montreal proved irresistible to biologists engaged in marine and fisheries research in the late nineteenth century. From a seasonal, transportable laboratory in 1898,

they graduated to a permanent year-round biological research station in 1908. In the 1960s it was joined, on the same section of the shore, by the Huntsman Marine Science Centre, and in 1971, on the other side of the peninsula, by the Atlantic Salmon Federation. The latter is dedicated to the well-being of the wild Atlantic salmon and the two former, in their applied research, have looked increasingly to the needs of aquaculture as wild fish stocks have continued to decline. To date, only salmon are raised in the sea cages but the prospective species list includes halibut, cod, and haddock.

Scientific research institutions, upmarket tourism, historic houses and buildings in the old town core, and a fringe of large summer houses—many of which are now occupied throughout the year—have given St. Andrews a comforting, established look. American residents, both summer and year-round, have also given it an international flavour. The post-Revolutionary hostilities between national governments had little effect on seaboard communities. All summer long, Canadian and American flags flank the doorways of inns, hotels, bed and breakfasts, and even private houses. But just as street names with royal associations alerted British officials to the Loyalist sacrifice, so today does the occasional Union Jack and the defunct but stately Red Ensign (the former Canadian flag) remind our American neighbours, and forgetful Canadian ones, that our strongest allegiance once lay overseas.

—*Ronald Rees*

FACING PAGE: The rooftop garden of the Fairmont Algonquin offers a panoramic view of St. Andrews and the St. Croix estuary toward Eastport, Maine.

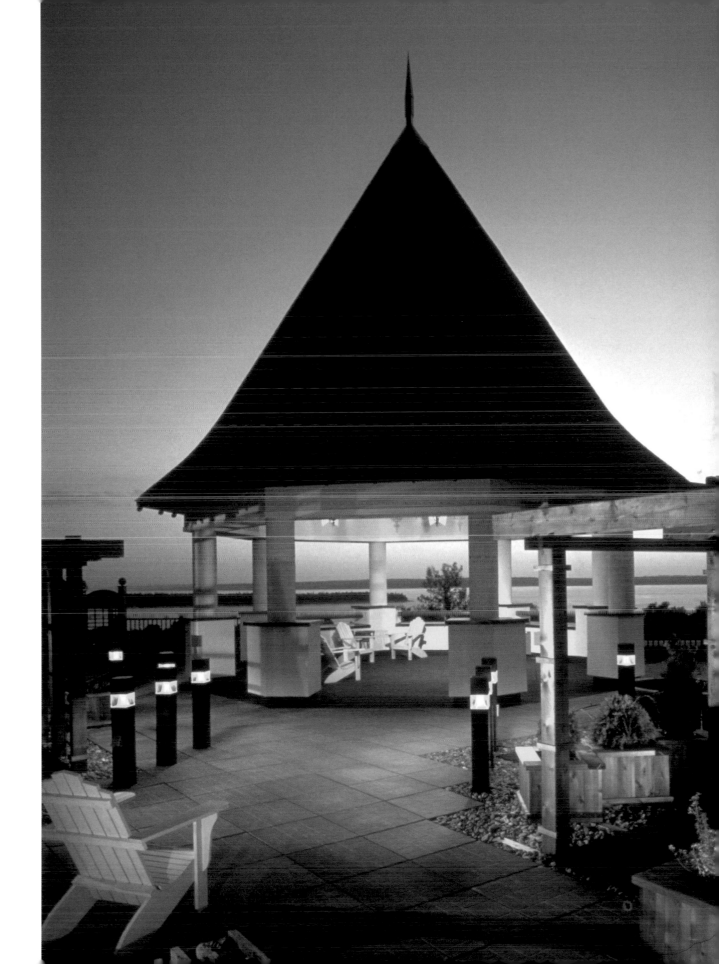

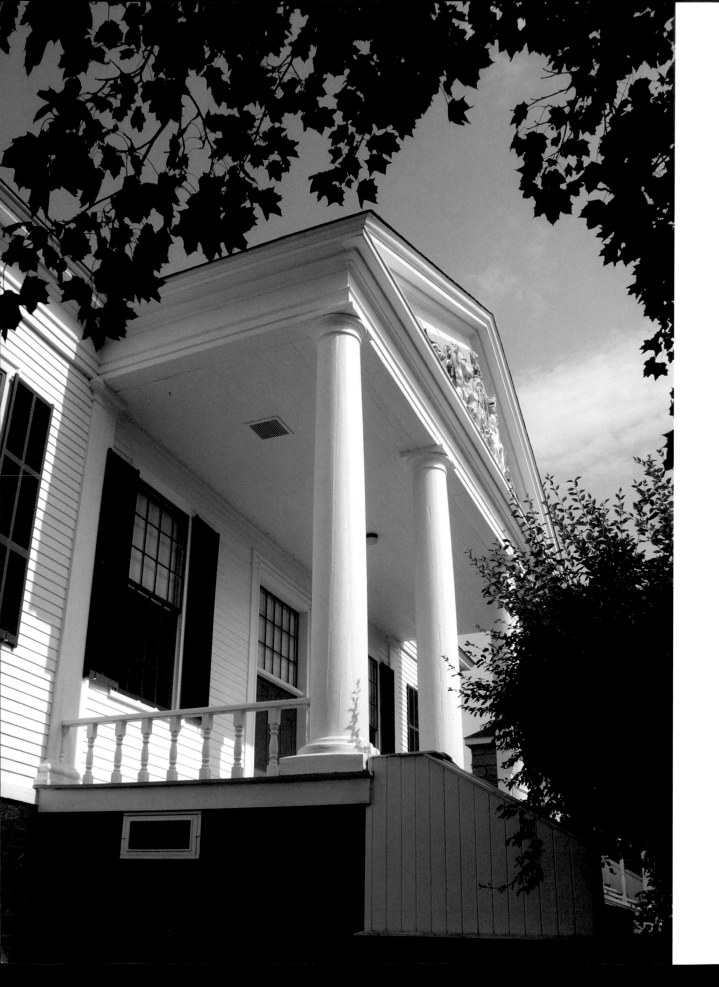

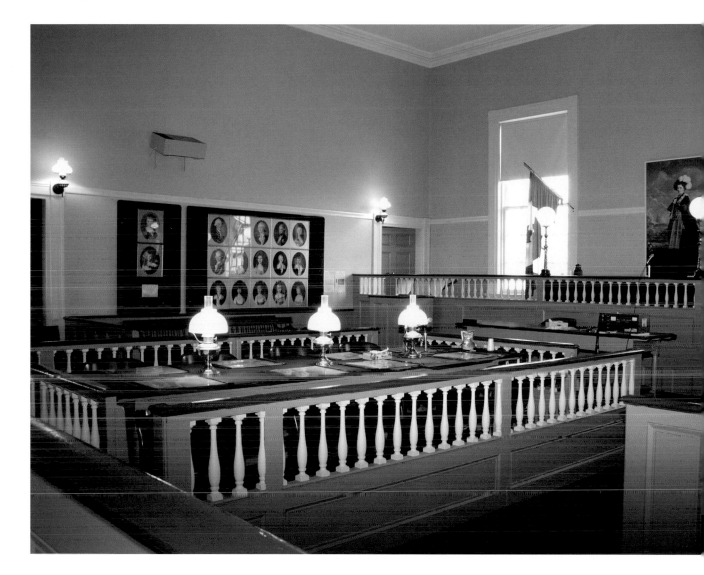

ABOVE: Inside the courthouse, which is still in use today, portraits of the British royal family at the time of construction are grouped together on the wall as a constant reminder of the town's ties to England.

FACING PAGE: Designed by Thomas Berry, the Charlotte County Courthouse (1840) displays a pediment with the royal coat of arms supported by four Doric columns.

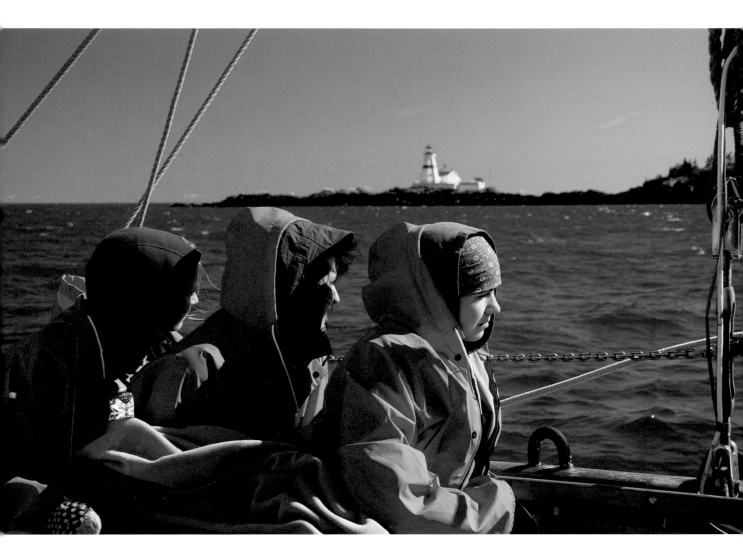

ABOVE: Even while you are waiting to spot a whale, you'll never be bored on a whale watching tour because of all the islands, birds, seals, weirs, lighthouses, and fish farms. There is so much to see!

ABOVE: A walking trail, one of many on Grand Manan, separates the Castalia Marsh from the open water.

OVERLEAF: These clam diggers are seeking out their harvest on the tidal causeway to Minister's Island.

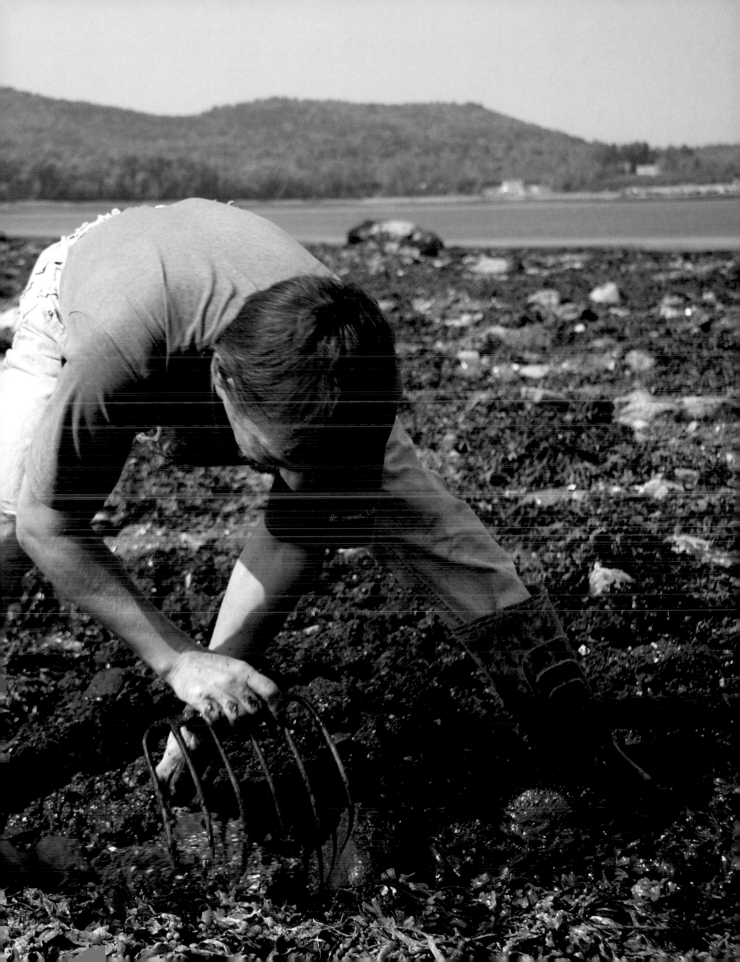

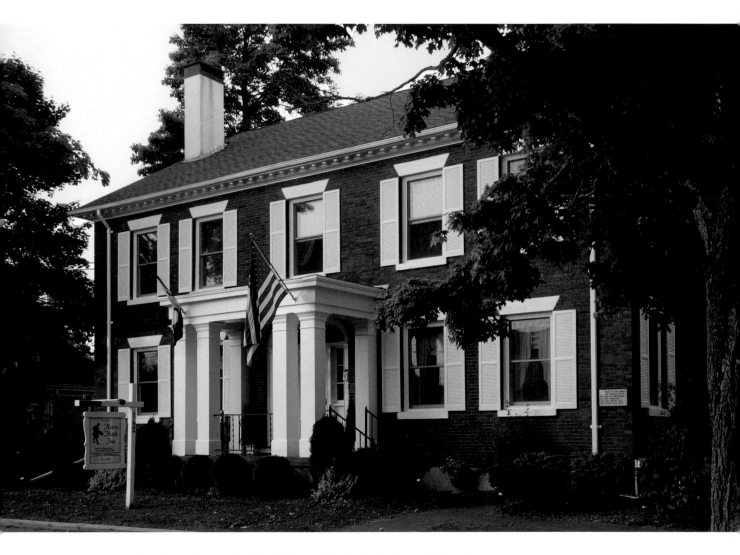

The Georgian style Harris Hatch Inn (1840) was built by Harris Hatch with bricks that were made and fired on site.

ABOVE: The Ross Memorial Museum (1824) was purchased by Henry Phipps Ross and his wife to display their private collection of furniture and decorative arts. The Ross Memorial Library was constructed in the late 1970s using funds left by the Rosses and designed according to their specifications.

A bust of Charles Lindbergh (by the Rosses' personal friend Cyrus Dallin), a quadruple-plate silver tea set by Derby Silver Company of Connecticut, and a bookcase by Lordly & Howe of Saint John (circa 1890) are available for viewing at the Ross Memorial Museum.

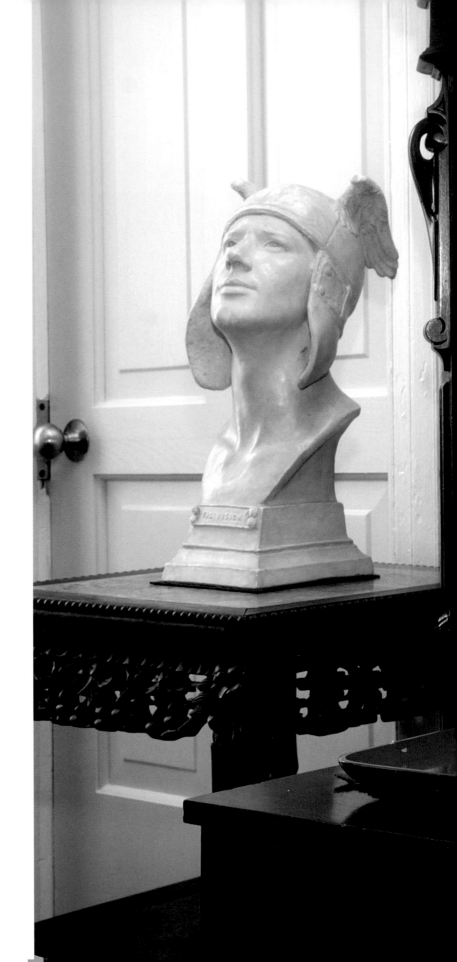

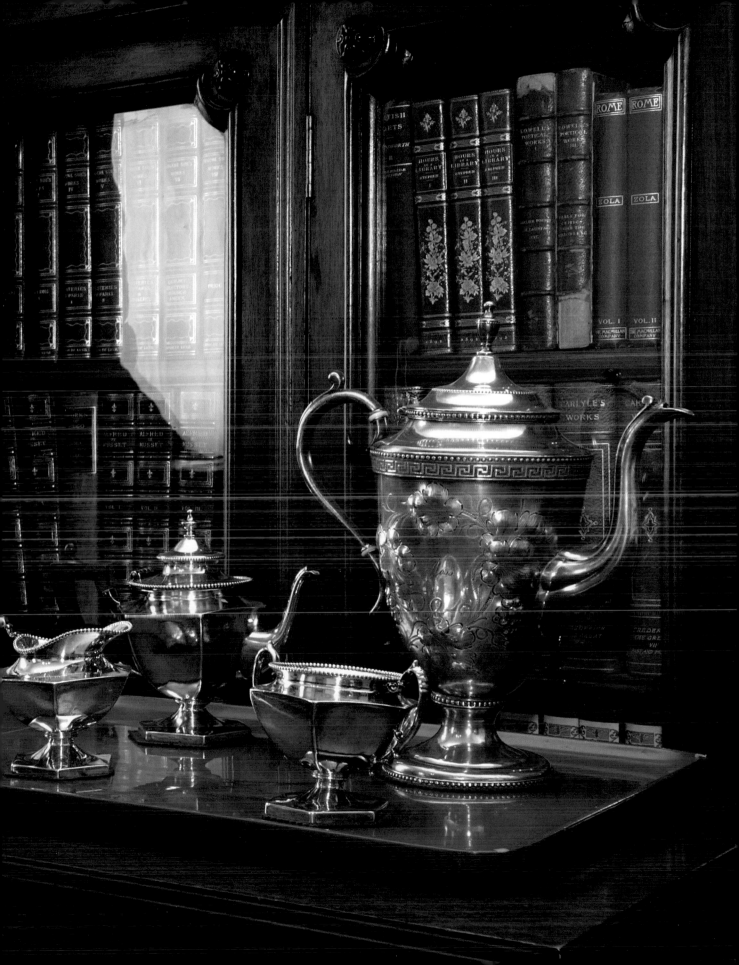

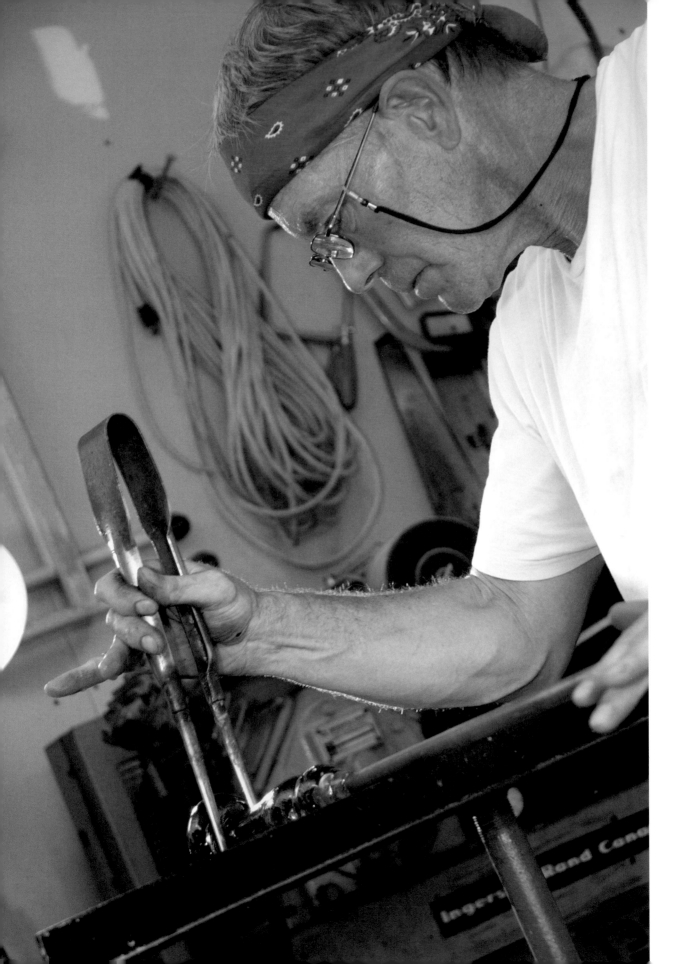

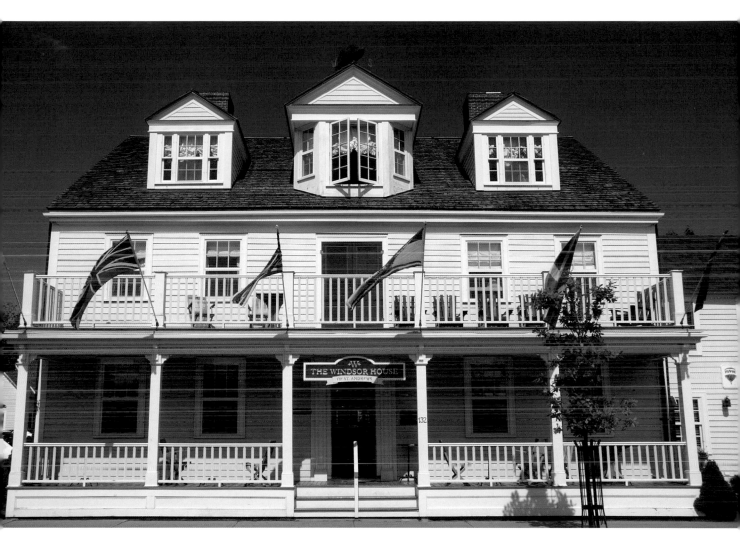

ABOVE: The Windsor House (circa 1798) was originally built for Loyalist Captain David Mowat but in later years became a hotel and stagecoach stop. The building now stands as a beautifully restored reminder of the past.

FACING PAGE: Glass-blower Jon Sawyer has been crafting quality vases, mugs, glasses, paperweights, and sculptures in St. Andrews for the last twenty years.

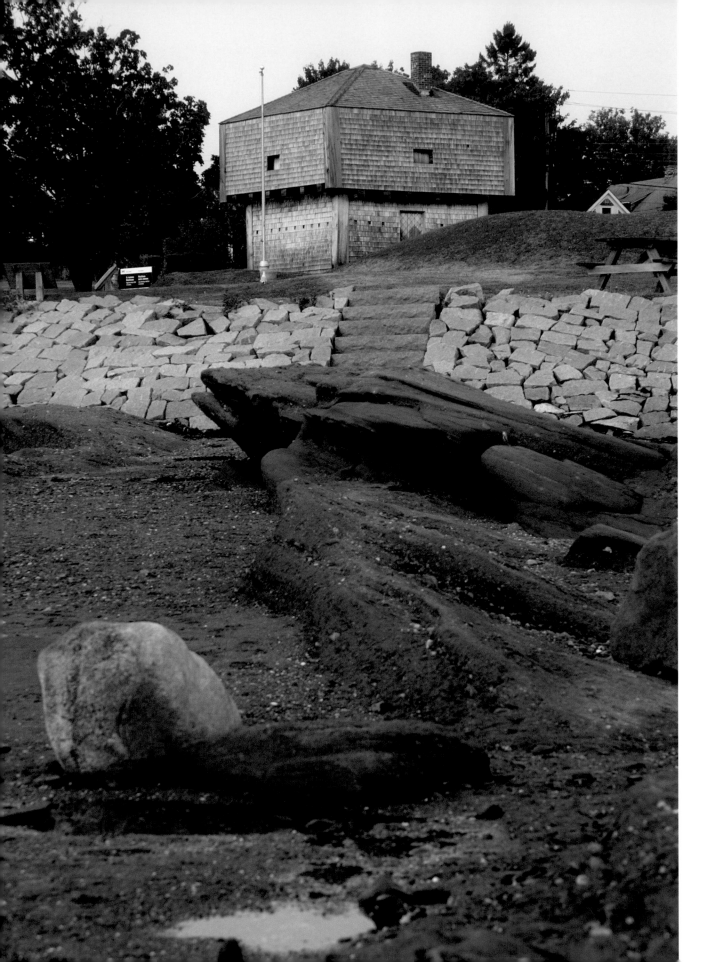

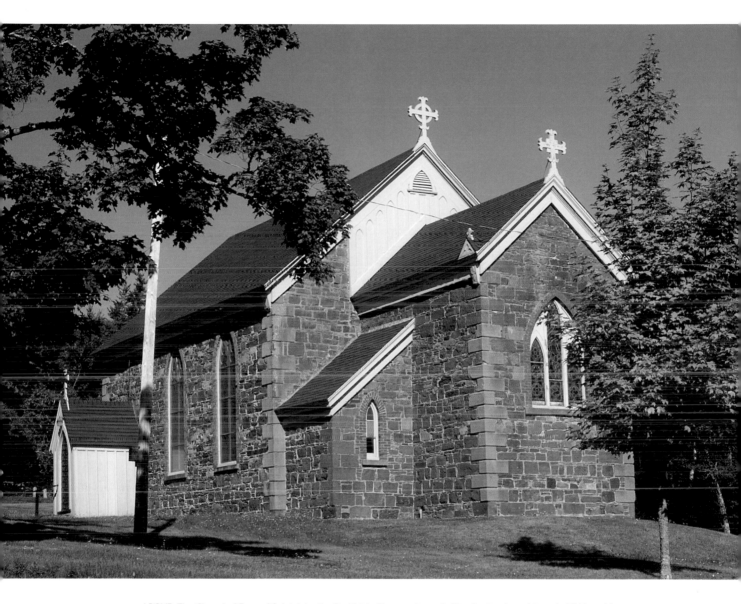

ABOVE: The Chapel of Ease of Saint John the Baptist in Chamcook was built using local sandstone in 1846, and it remains one of the only stone churches in the area.

FACING PAGE: The West Point Blockhouse is now the only surviving fortification of the original three fortifications built in 1812–13 to defend the town of St. Andrews.

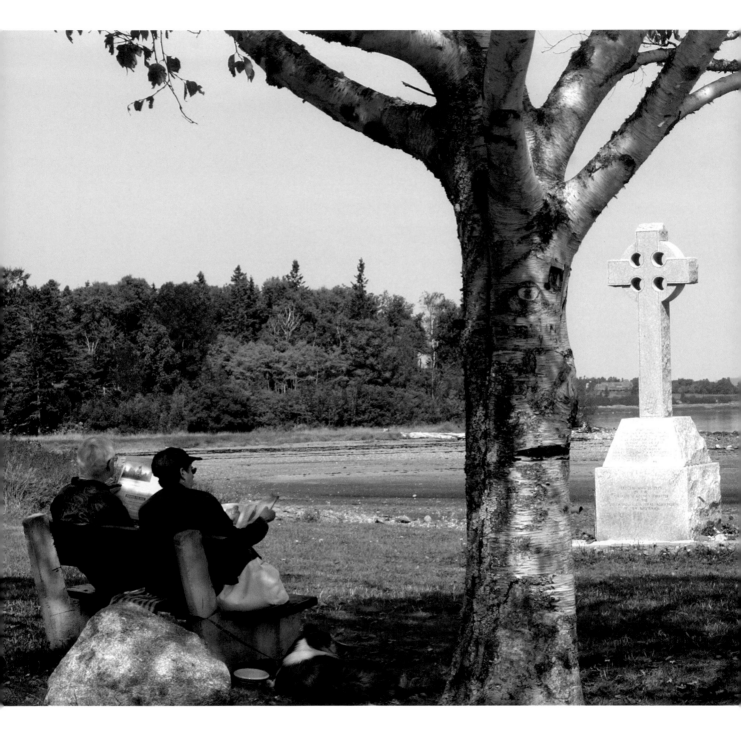

This Celtic cross facing Hospital Island was erected by the Irish Canadian Cultural Association of New Brunswick in memory of those who died and were buried on the island after fleeing Ireland's great potato famine.

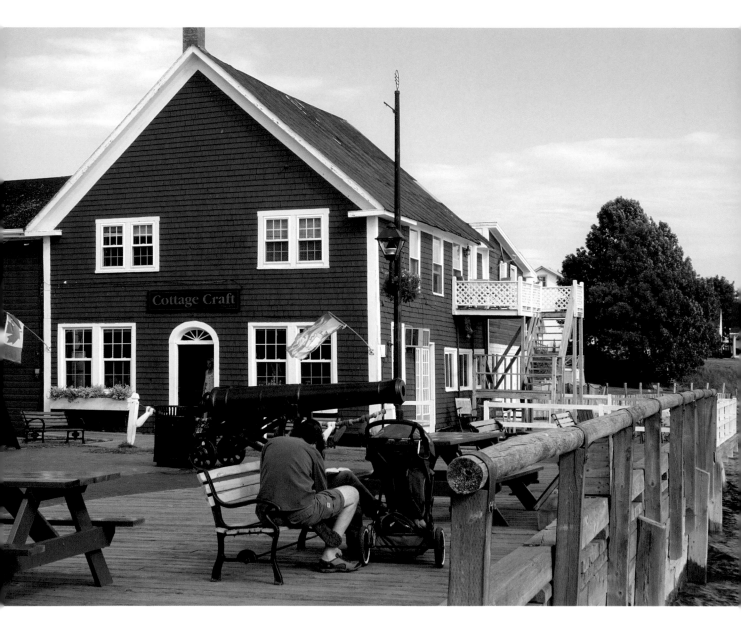

ABOVE: Cottage Craft, a business started by Helen Mowat in 1915 that supplied woollen products characteristic of this country, was turned over to the Ross family who have continued running it in the same manner ever since.

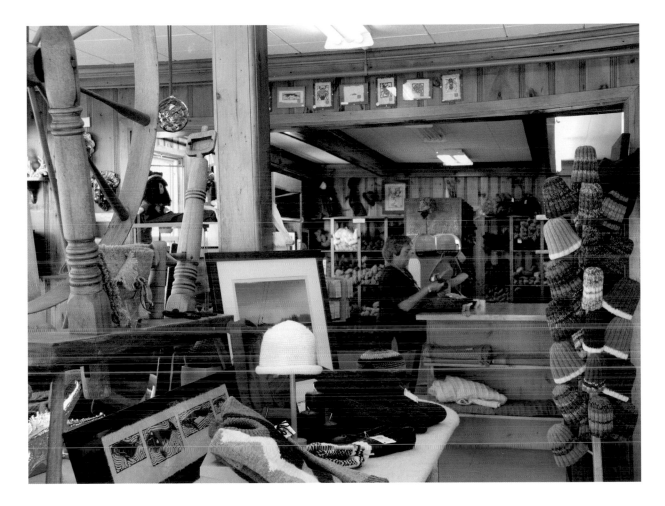

ABOVE: More than two hundred knitters, weavers, and handcrafters throughout the province supply woollen products for these shelves. They often use the popular Briggs & Little wool milled in New Brunswick.

OVERLEAF: The side of the local hardware store provides a canvas for St. Andrews artist Geoff Slater to depict the town's waterfront the way it looked a century ago.

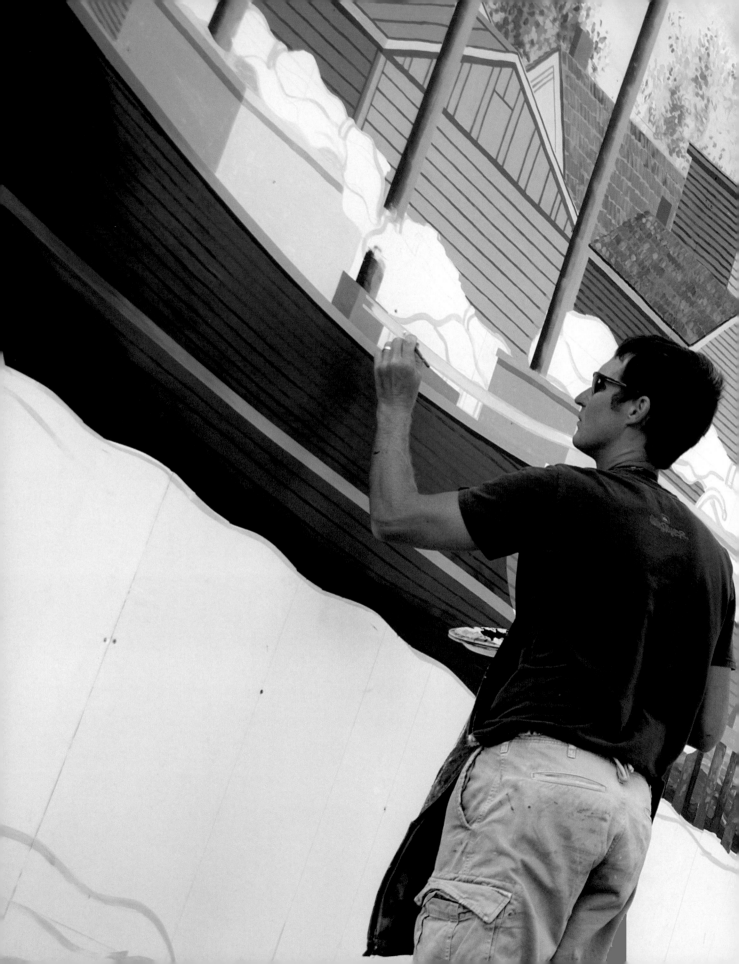

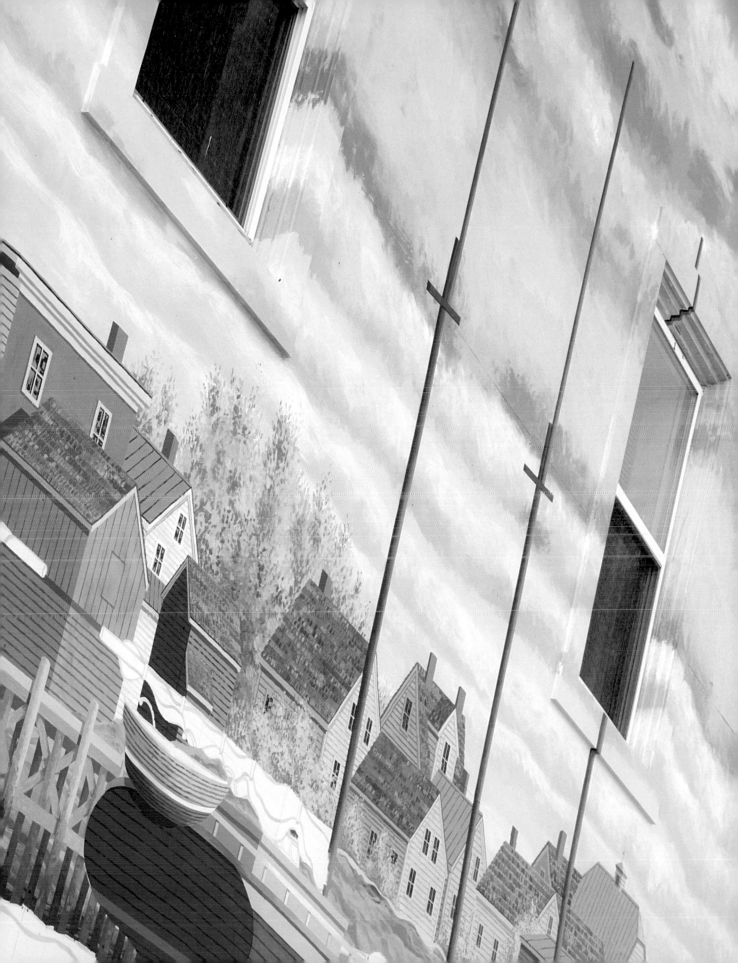

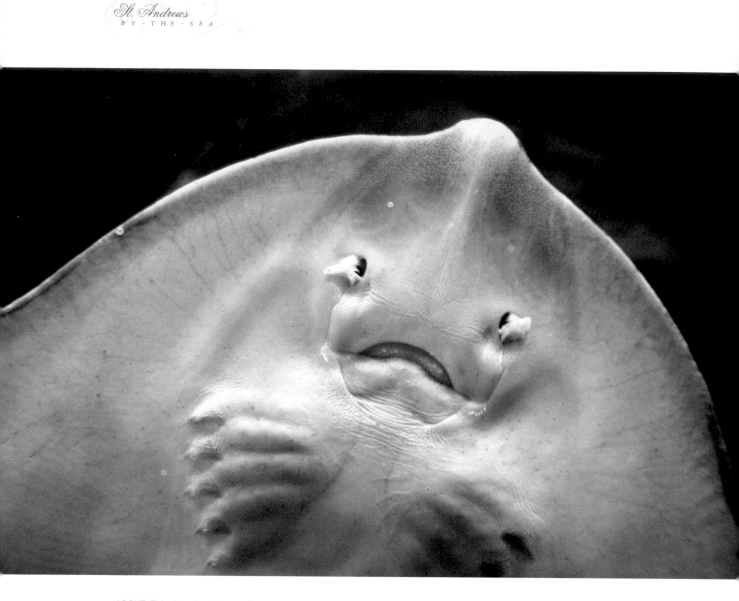

ABOVE: *This skate is only one of the many wonderful fish and sea creatures in the Huntsman Marine Museum, which holds a variety of species not normally accessible to the general population.*

FACING PAGE: *One of several kinds of sturgeon raised for breeding is examined at the Huntsman Marine Science Centre, the site of extensive research and education in marine biology.*

OVERLEAF: *The sun rises over Grand Manan's eastern coast while the fishing boats rest calmly before heading out for the day.*

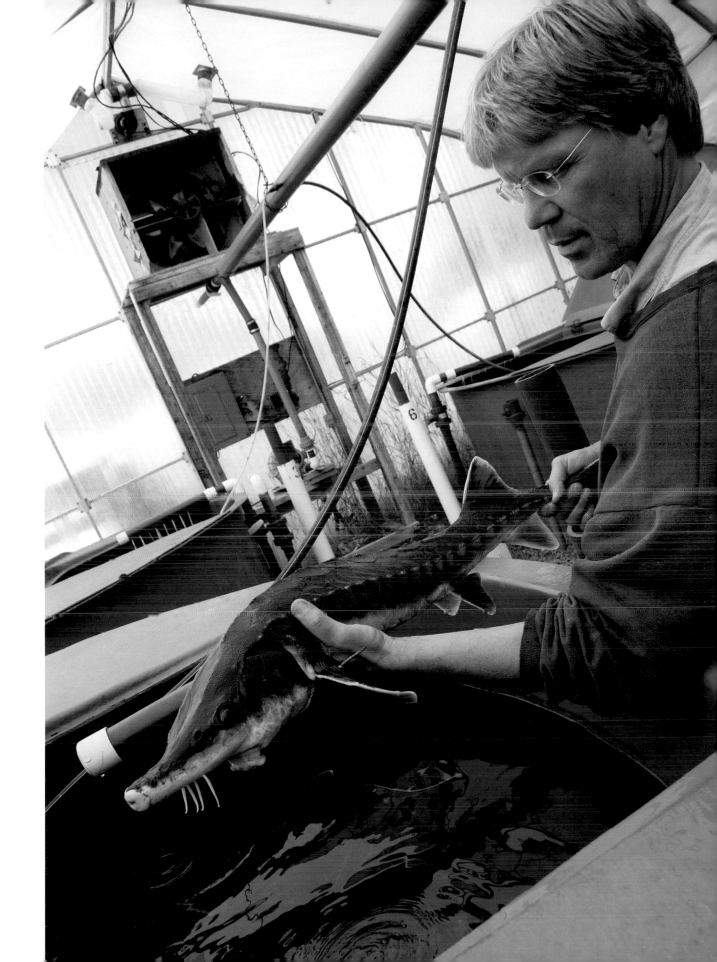

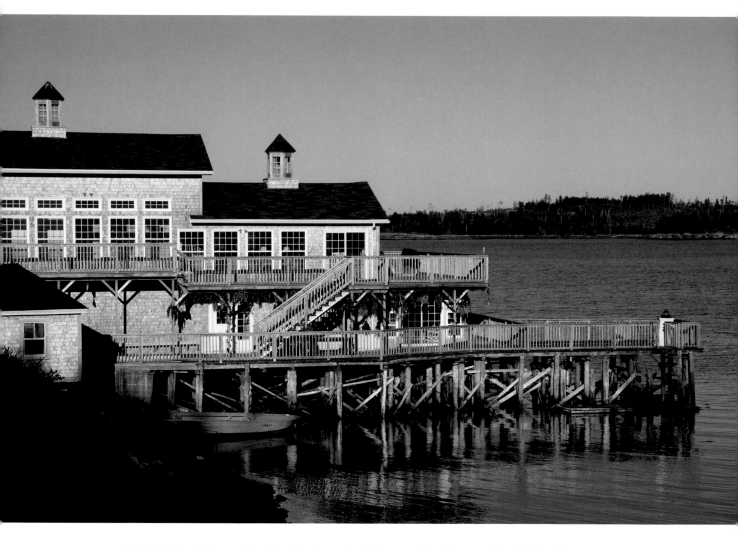

*ABOVE: The Carr Cottage on Deer Island has been extensively renovated and features a fantastic view of
Richardson Cove.*

*FACING PAGE: These fishing boats are packed together in Grand Manan's Seal Cove Harbour like sardines in an
open can.*

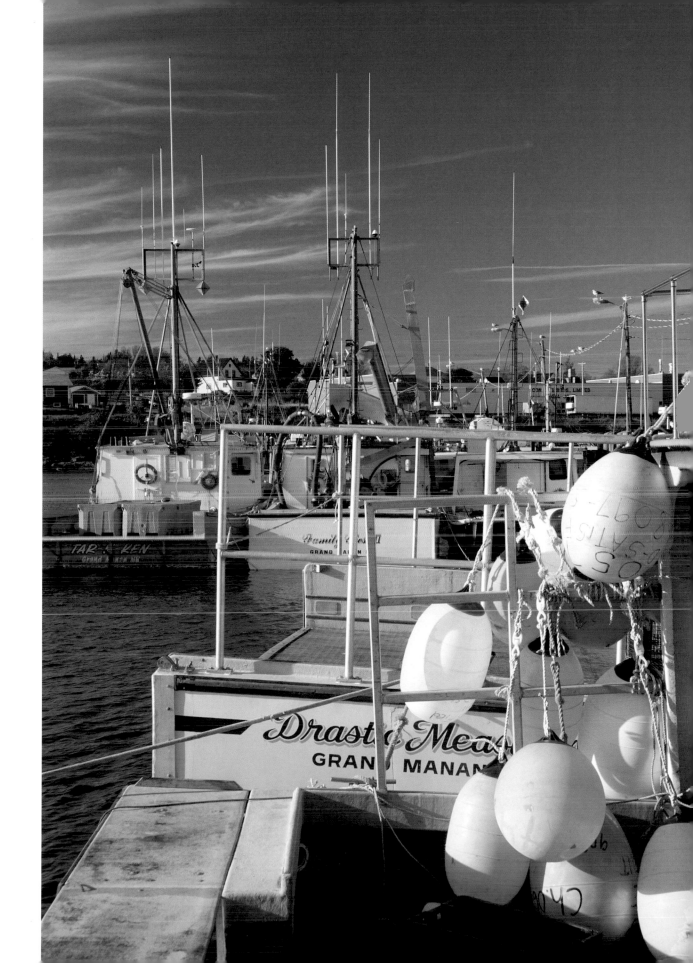

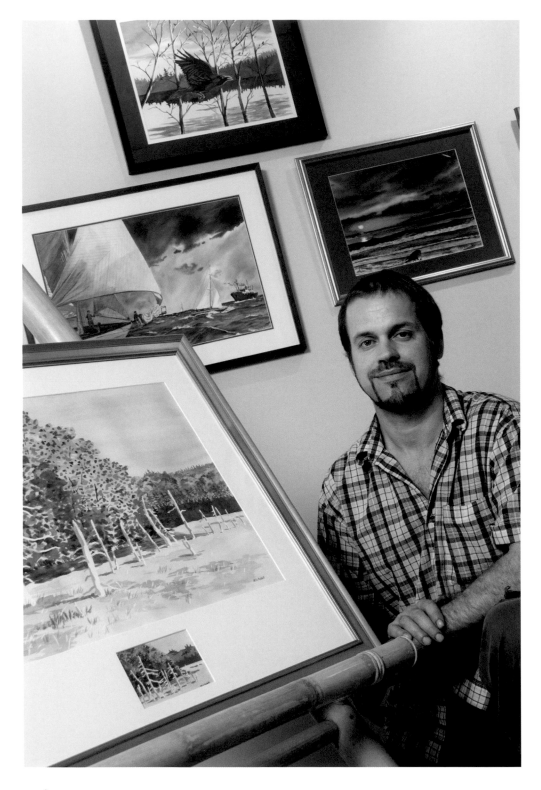

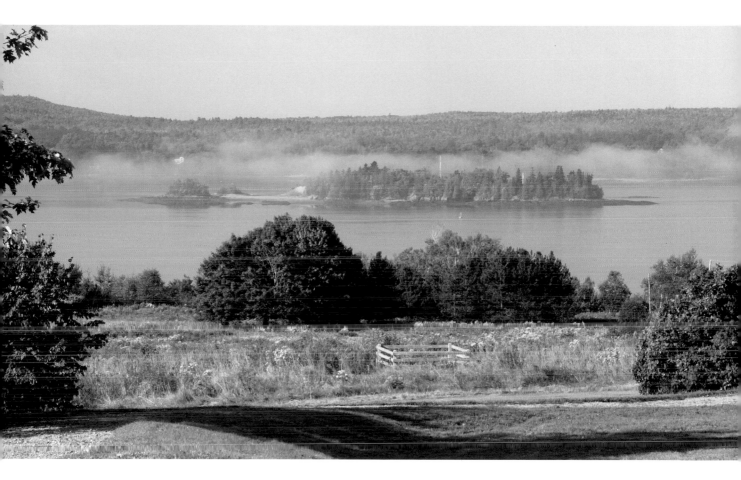

ABOVE: In 1604, Sieur de Monts and Samuel de Champlain were the first Europeans to attempt a permanent settlement on the Atlantic coast north of Florida. They chose St. Croix Island—it is now a National Historic Site.

FACING PAGE: Accomplished artist and fisherman Mike Fields paints watercolours of island life, including commissioned boat portraits, birds, and nature scenes.

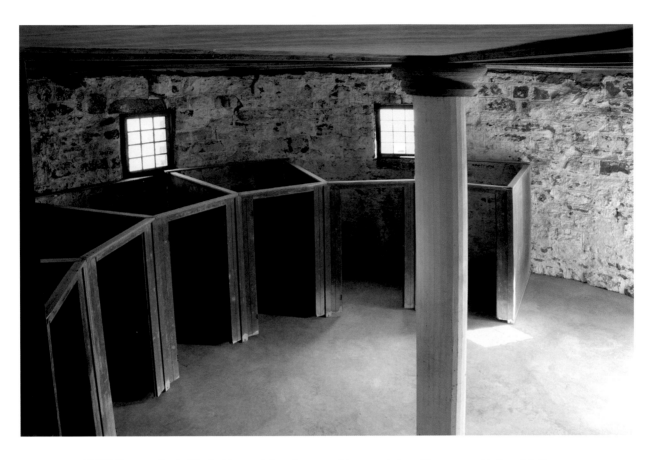

ABOVE: The upper level of the bathhouse at Covenhoven provides a great view of Passamaquoddy Bay while the lower level features changing stalls around the perimeter of its circular walls.

FACING PAGE: Built from stone from a local quarry, the bathhouse was constructed alongside a pool carved out of the sandstone on the beach of Minister's Island.

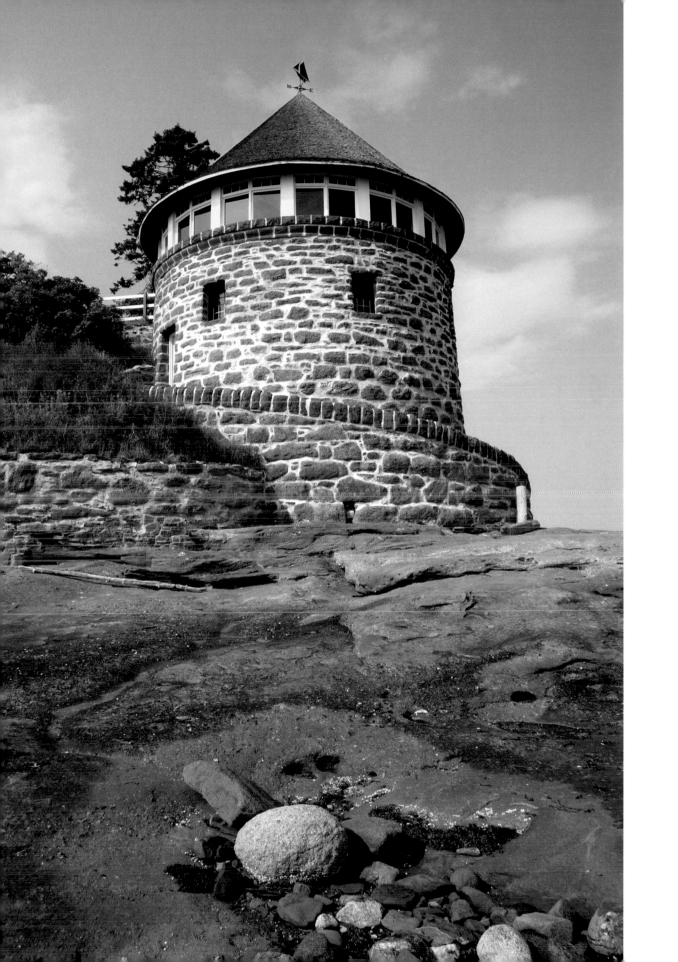

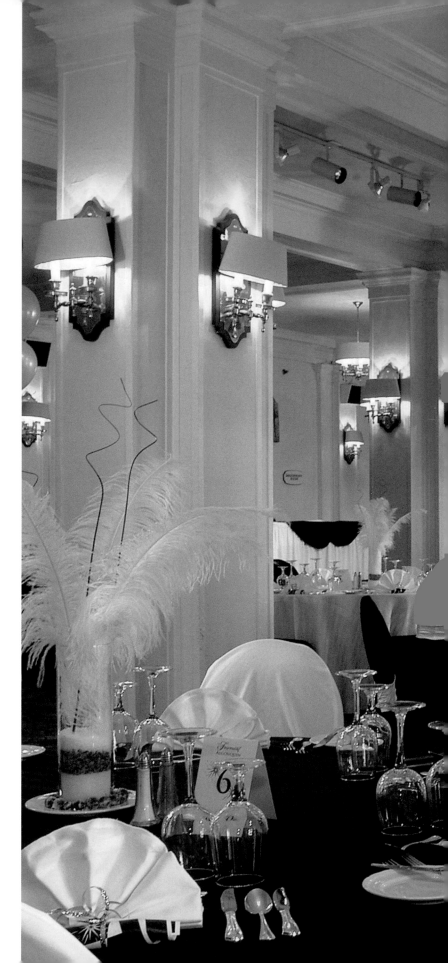

*The Fairmont Algonquin, with over
nineteen thousand square feet of
functional meeting space, can easily
cater to conventions, banquets, and
special events, from New Year's Eve
celebrations to wedding parties.*

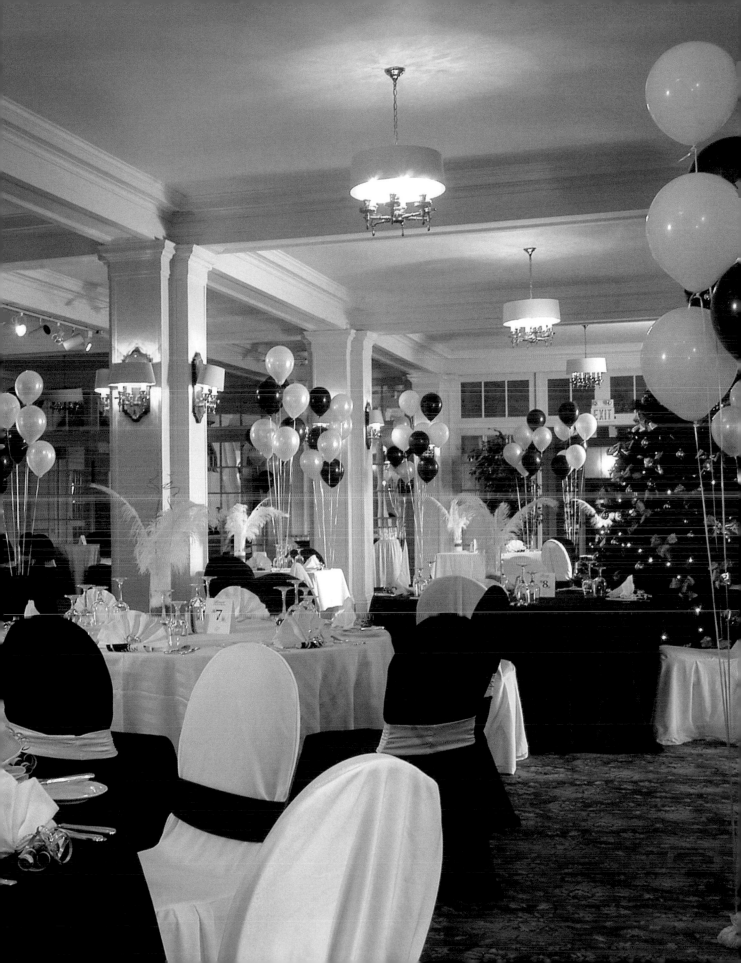

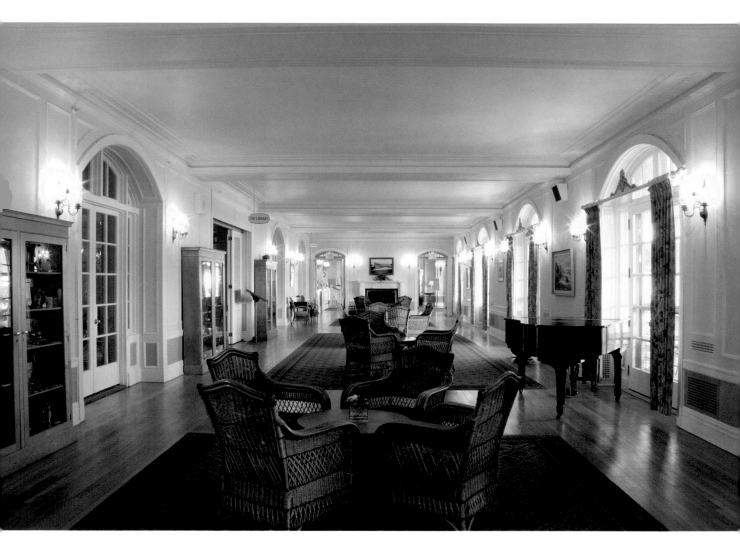

The lobby of the Fairmont Algonquin retains much of its original design as completed by Kate Reed, the first owner of the Pansy Patch, the bed and breakfast adjacent to the hotel.

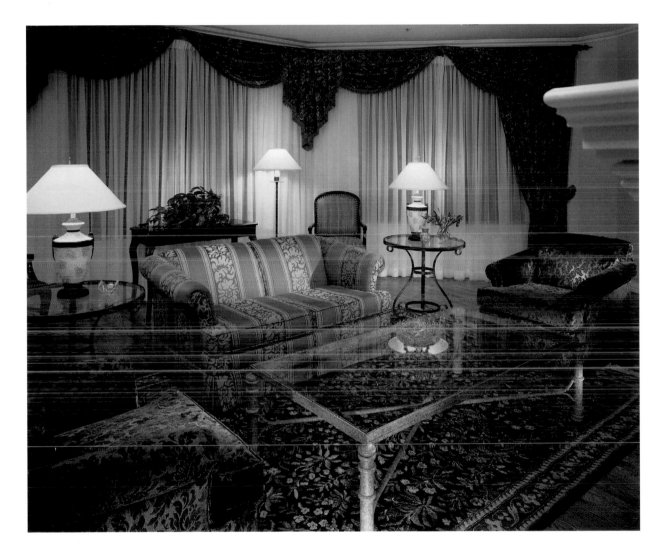

The warmth and elegance of the 234 guest rooms and suites provides a relaxing atmosphere for guests of the Fairmont Algonquin.

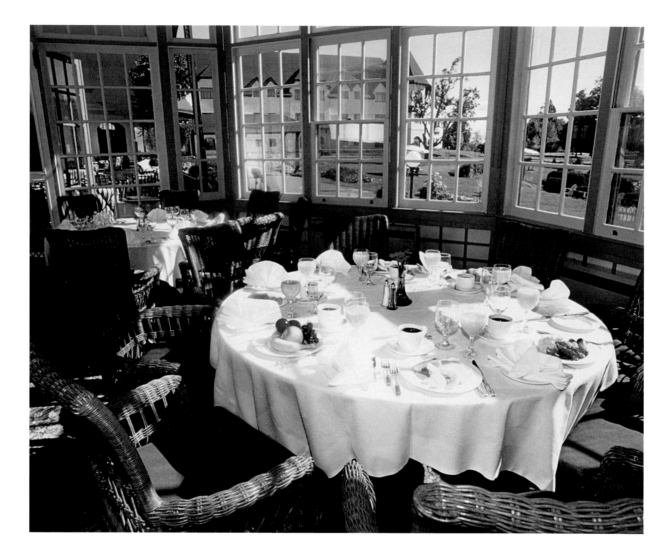

On the main level of the Fairmont Algonquin, guests may breakfast in the Passamaquoddy Room, which overlooks the beautiful gardens in front of the hotel.

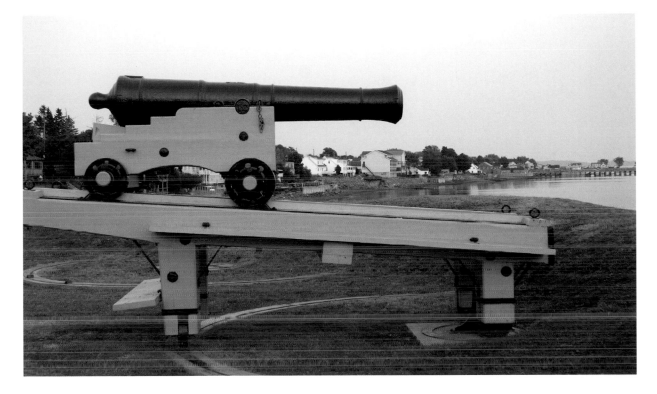

*The cannon perched in front of the West Point Blockhouse guarded the town of St.
Andrews from privateers and marauders from the south.*

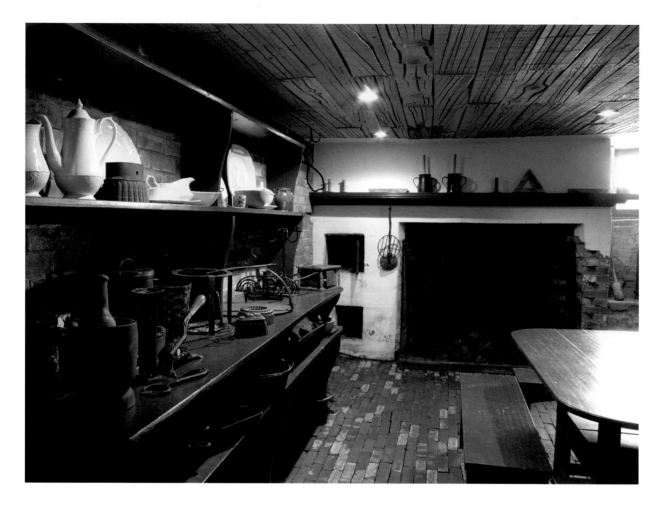

The 1820 neoclassical brick house of Sheriff Andrews features a basement kitchen with an imposing hearth equipped with a beehive oven.

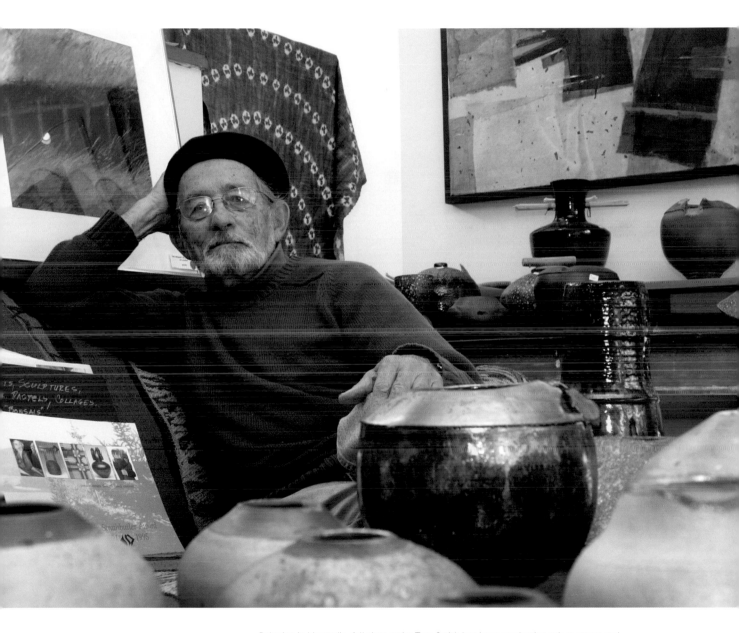

*Relaxing in his studio, full-time artist Tom Smith has been producting raku pottery and
paintings for many years.*

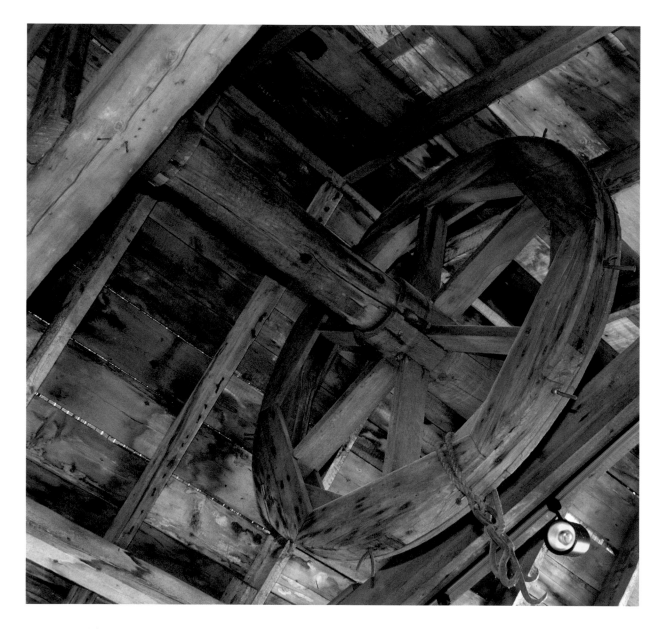

A few large wooden pulleys, which once hauled goods to the upper storey, may still be found in the old waterfront warehouses.

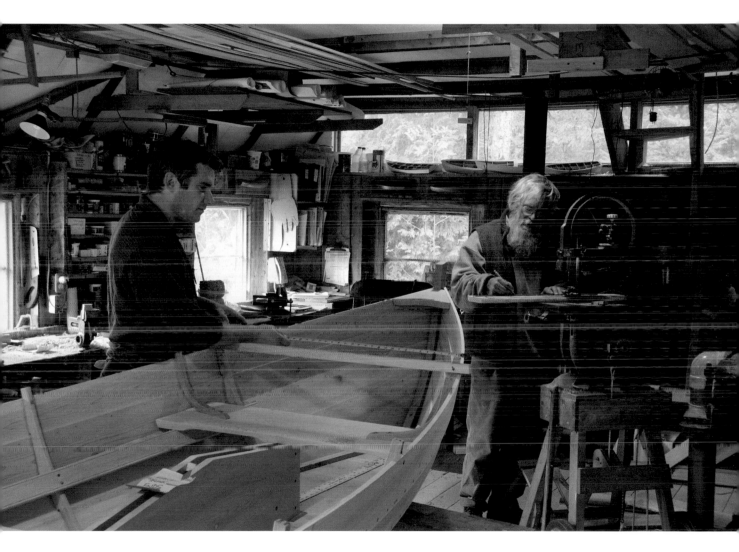

Just south of St. George, Harry Bryan Boatbuilders constructs dories, sailboats, canoes, and rowboats using traditional techniques with off-grid power sources.

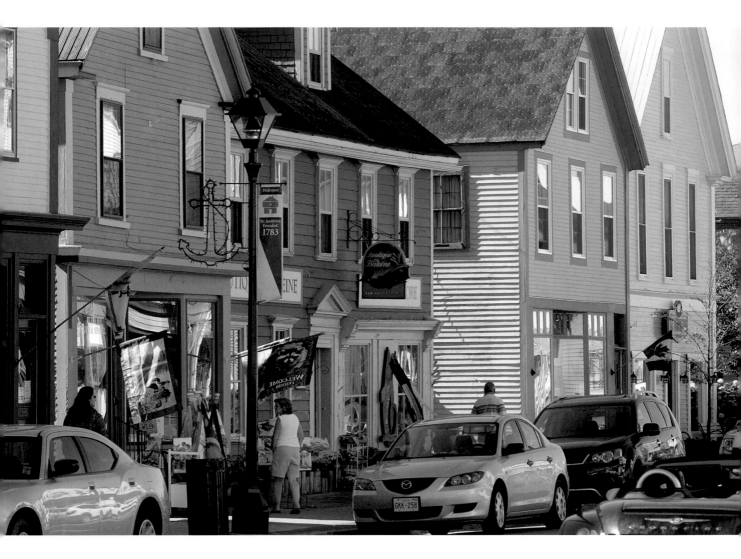

ABOVE: Boutiques lining Water Street painted in pastel summer shades lighten the spirits of those enjoying this seaside resort.

FACING PAGE: There are a variety of restaurants in the downtown area, some with patios overlooking the harbour, others in the comfort of a Victorian inn.

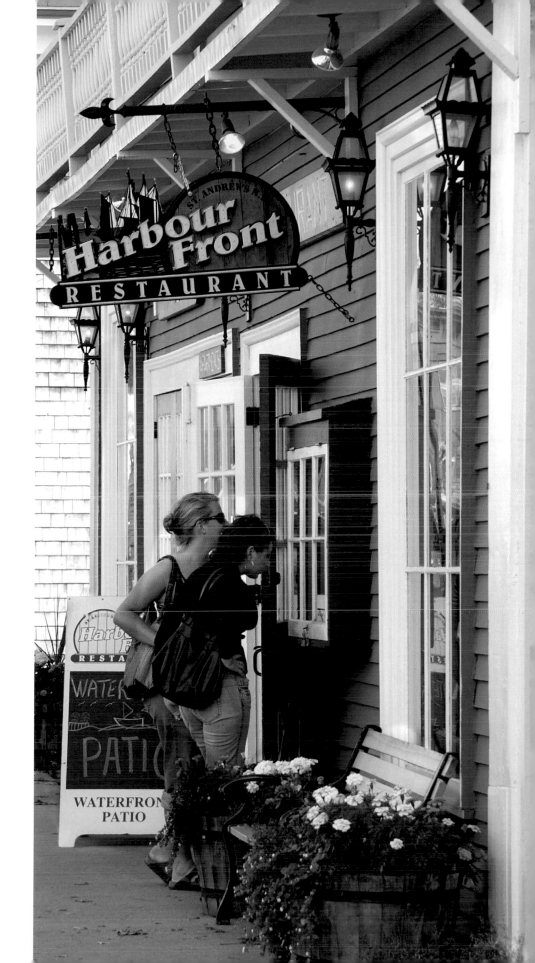

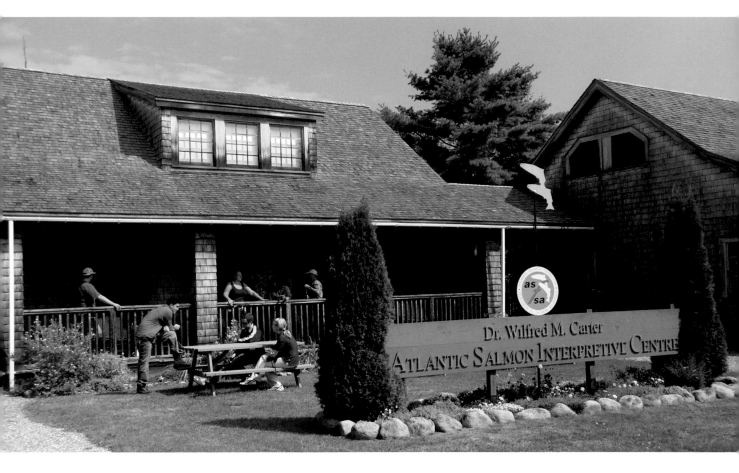

The Atlantic Salmon Interpretive Centre in Chamcook includes an aquarium, exhibit hall with informative displays, museum, and educational trails all dedicated to Atlantic salmon.

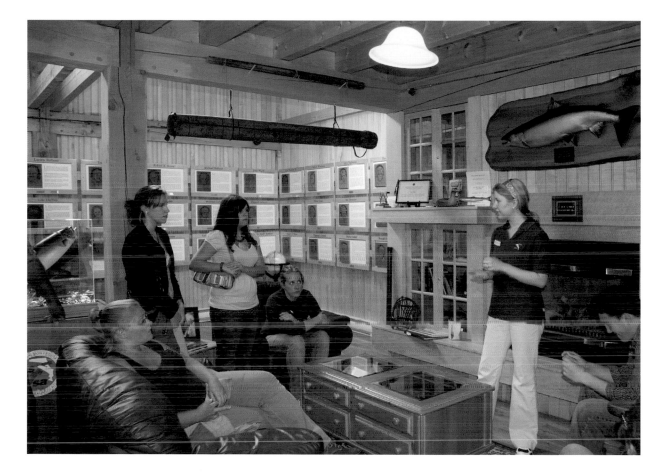

A reconstruction of a fishing lodge interior, hall of fame, and memorabilia related to fly fishing can all be found inside the interpretive centre.

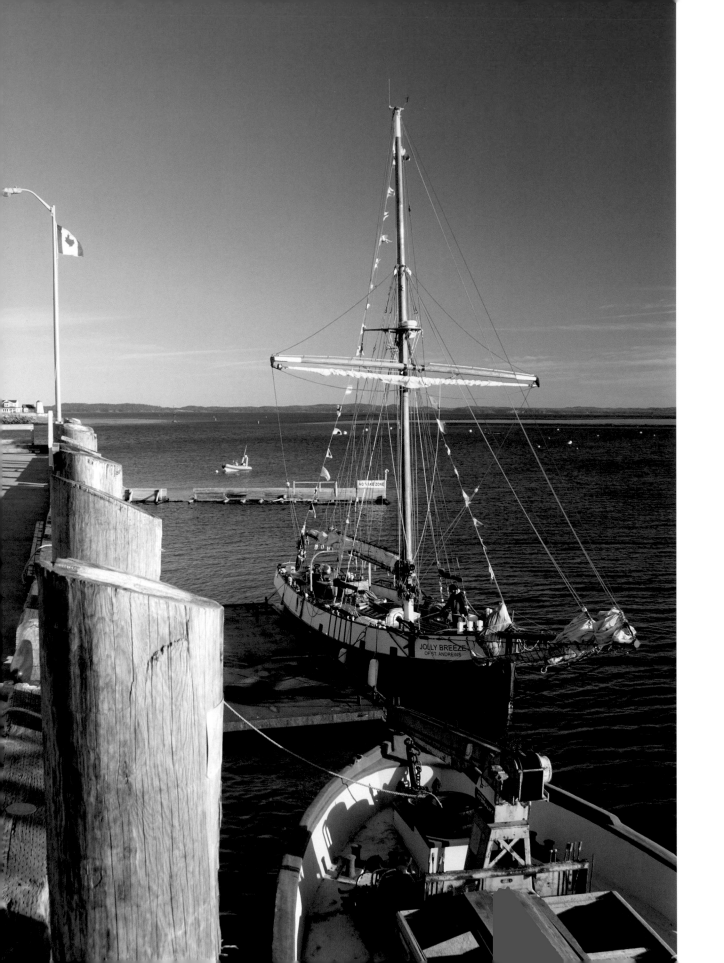

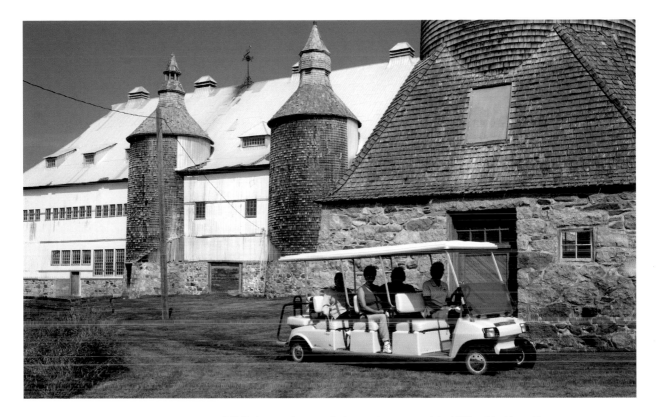

ABOVE: The massive two-silo barn and creamery of the William Van Horne Estate are among the first buildings to catch your eye upon arriving on Minister's Island.

FACING PAGE: Whale-watching adventures can be exciting aboard the Jolly Breeze, seen docked here at the St. Andrews pier.

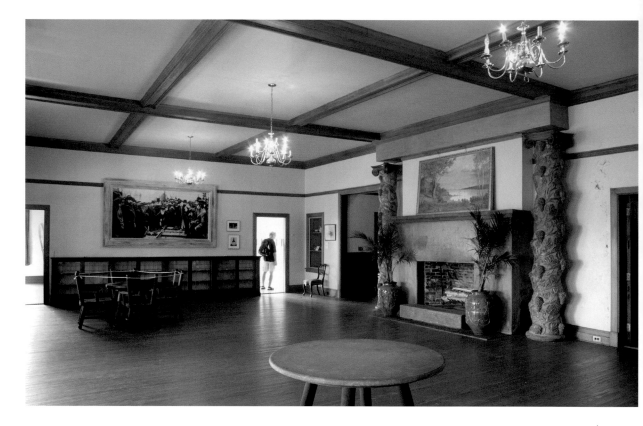

*ABOVE: William Van Horne's Covenhoven contains some fifty rooms, seventeen of which are
bedrooms, and also this immense drawing room with its rather unique fireplace.*

*FACING PAGE: Kerosene-fired engines once powered this windmill that supplied water from a large
underground storage tank to Van Horne's estate on Minister's Island.*

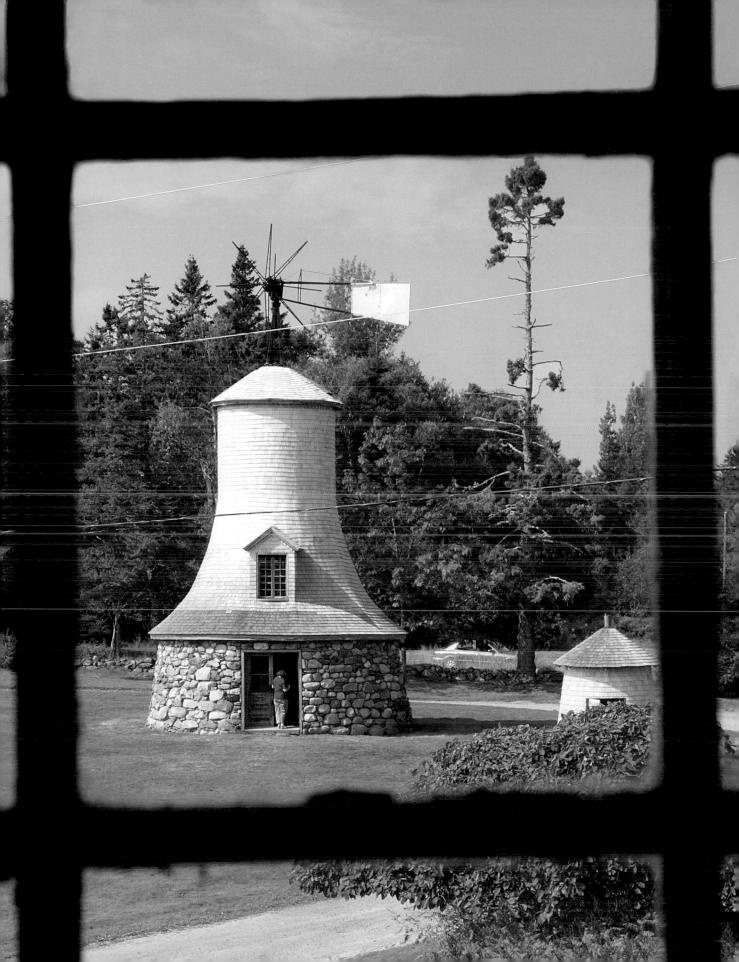

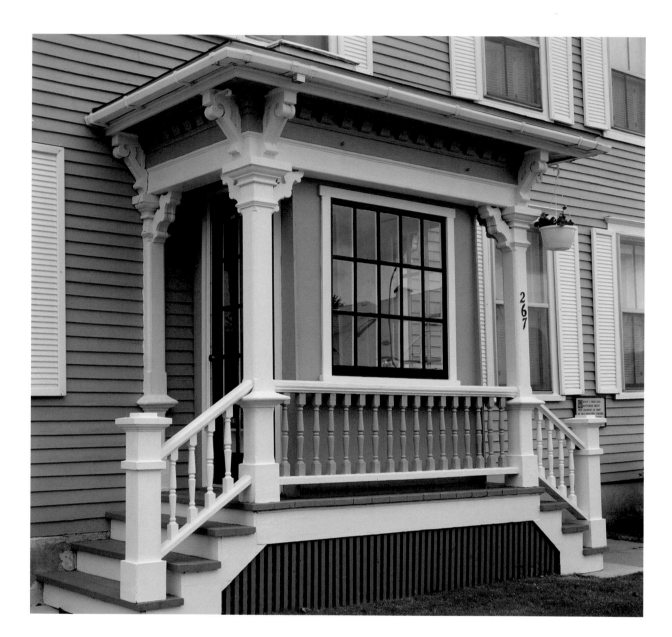

*The main entrance to the Mallory House (1810) retains grandeur and charm due to its
extensive architectural adornments of the late 1800s.*

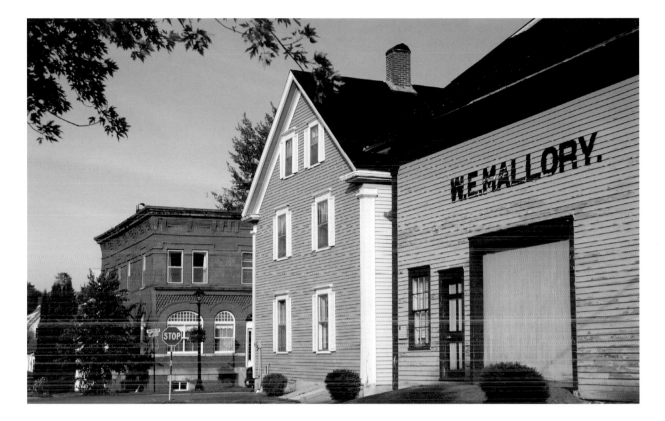

Beside the Mallory Barn, which was once used as a livery stable and then for curing and storing fish, is the Mallory House and across Water Street is the former Land Company Office.

*Kingsbrae Gardens has a long
history of fine gardens on these
twenty-seven acres. It features
a cedar maze, two ponds, a fully
functioning one-third scale Dutch
windmill, and over 2,500 varieties
of trees, shrubs, and plants.*

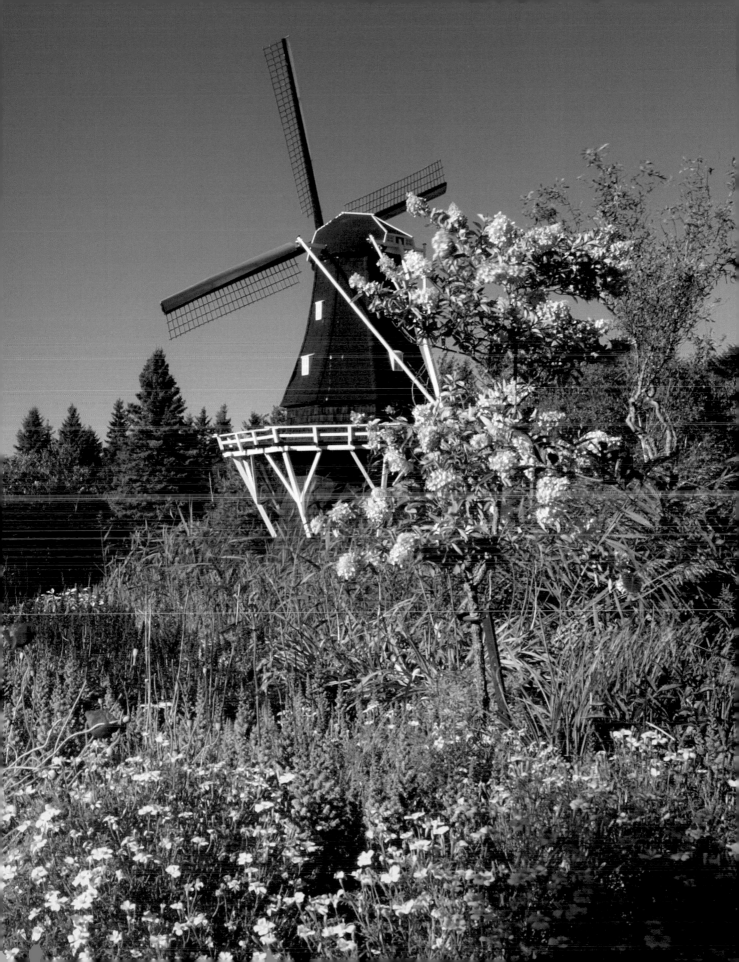

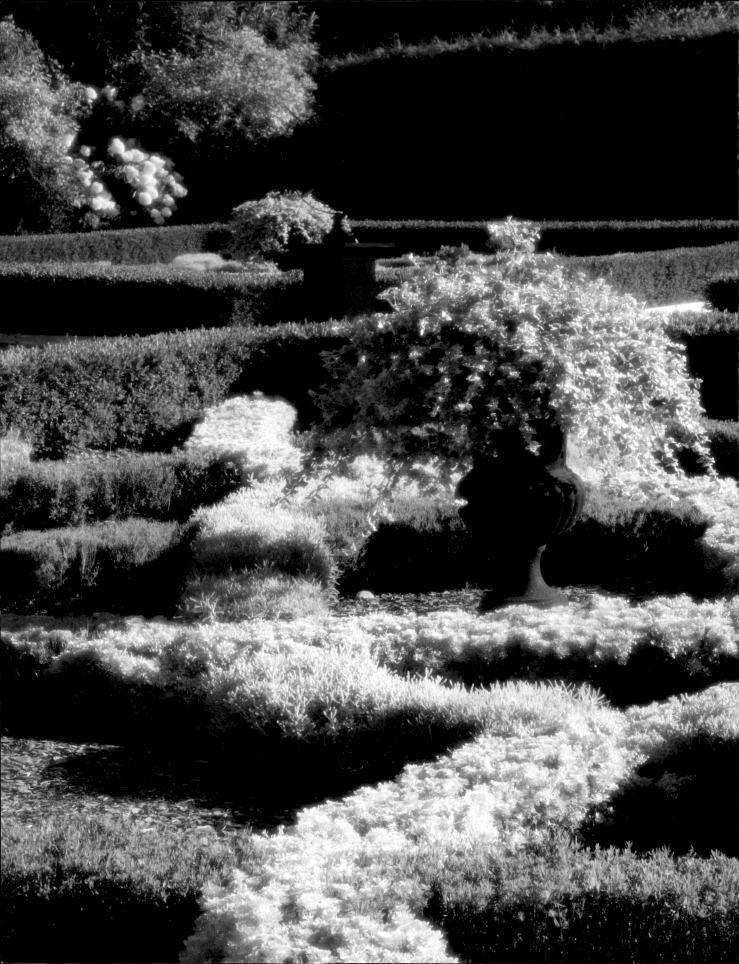

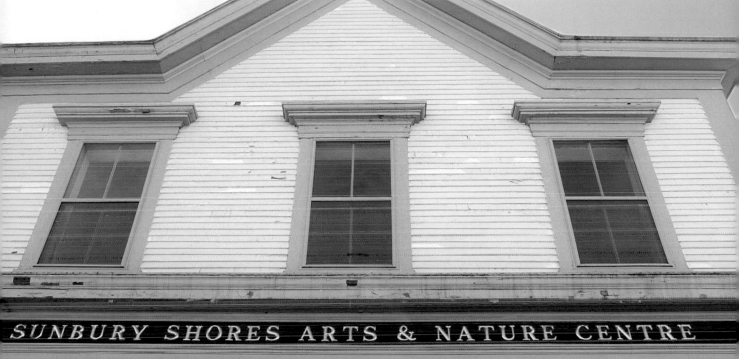

ABOVE: Sunbury Shores Arts & Nature Centre is a not-for-profit organization with a renowned art gallery on its main floor.

FACING PAGE: The knot garden at Kingsbrae is paralleled by the rose, perennial, and cottage gardens, and interspersed with several sculptures.

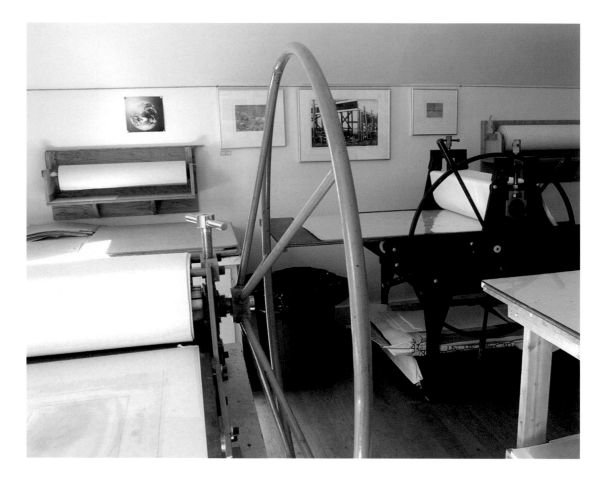

ABOVE: Equipped with a print shop and a large upper level, Sunbury Shores has adequate facilities to conduct a variety of workshops and seminars pertaining to the arts.

FACING PAGE: The wooden signs on Water Street maintain the town's character of days gone by.

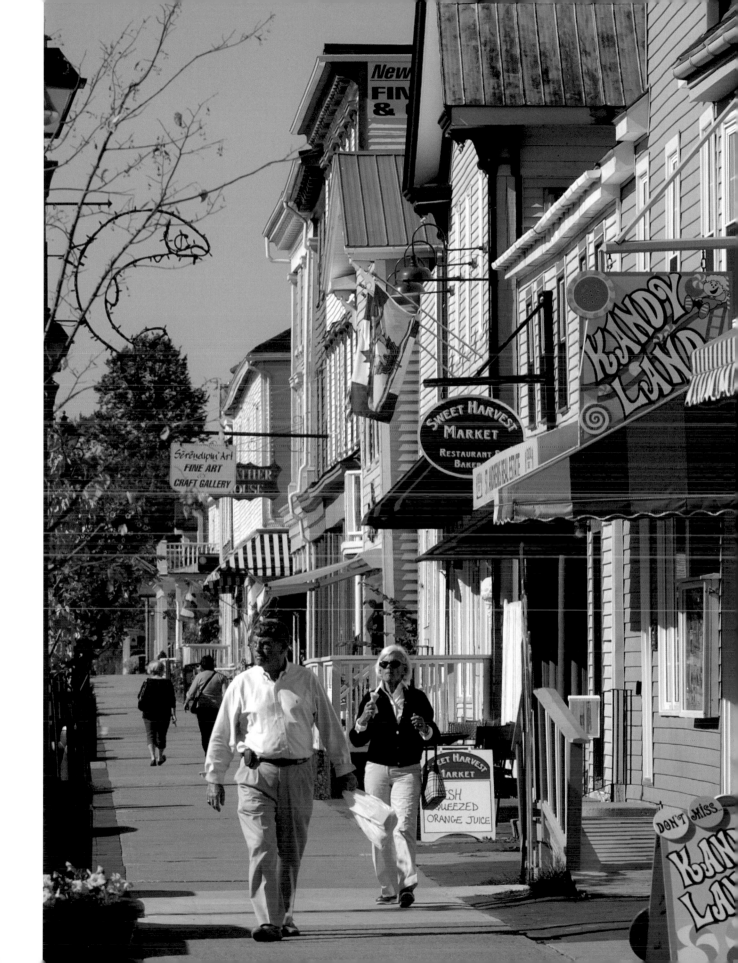

The Pansy Patch is a replica of a
Normandy farmhouse. This bed
and breakfast features a turret and
a thatched-style roof designed by
Charles Sax in 1912 for Hayter and
Kate Reed.

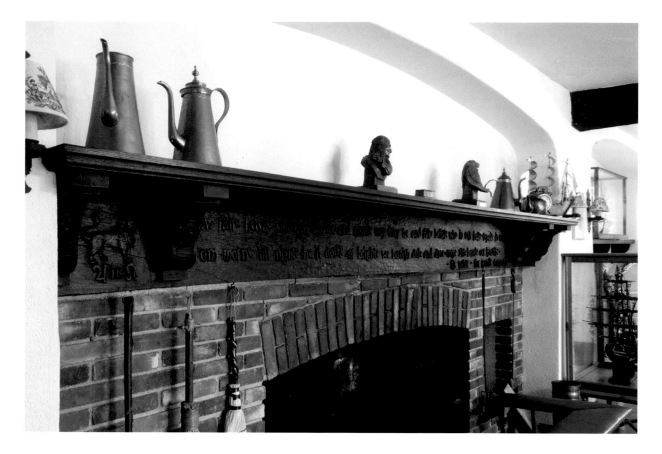

*The Pansy Patch has also retained much of its interior beauty, as shown by
this engraved mantelpiece.*

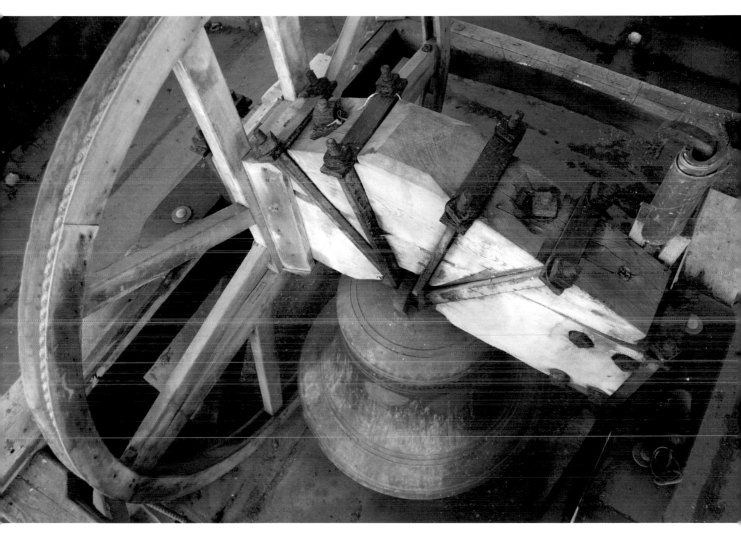

*Inside the bell tower of All Saints Anglican Church on King Street is
the original bell, which dates back to 1866.*

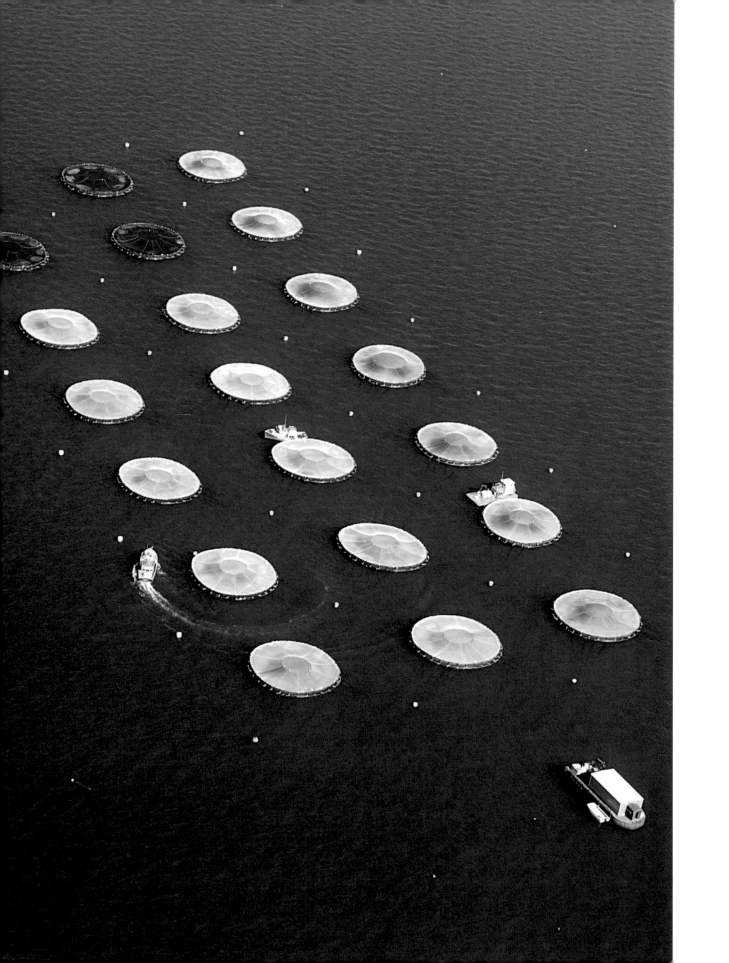

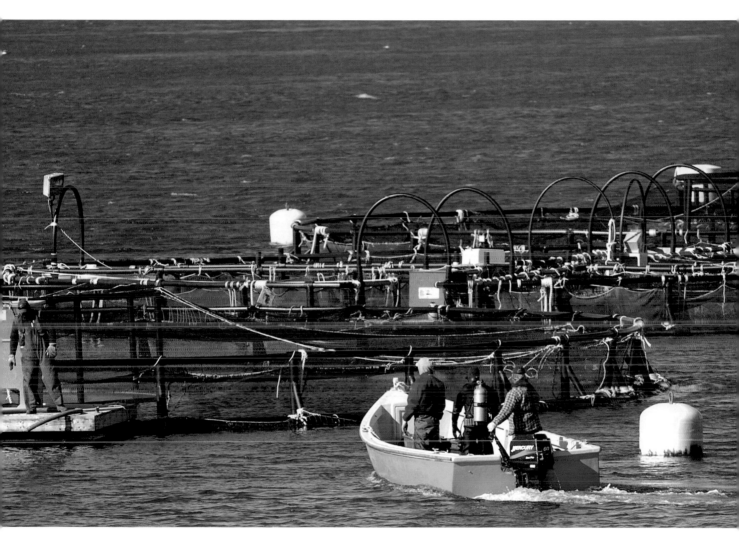

ABOVE: A fish farm tucked into the cove at Green's Point near the Deer Island ferry requires constant labour to operate smoothly.

FACING PAGE: The fish farms, as seen from above, are remarkable for their precise placement in the open waters.

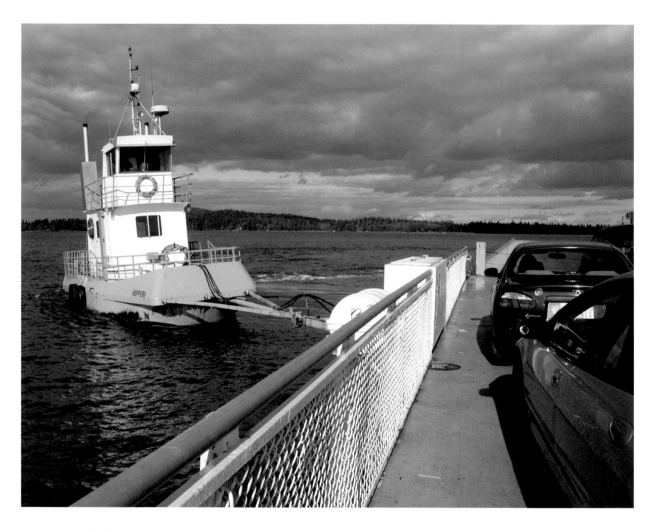

ABOVE: The Hopper II, which commutes between Deer Island and Campobello Island, is a "tug & barge" style ferry where the wheelhouse pivots from one end of the barge to the other to change direction.

FACING PAGE: Each whale-watching company offers a unique experience, but there is always a relaxed pace at the town pier that invites one to slow down, have a coffee, and chat in the summer sun.

OVERLEAF: The falls and ravine of the Magaguadavic River nestle the 1902 brick powerhouse and pulp mill, which has become a trademark for the town of St. George.

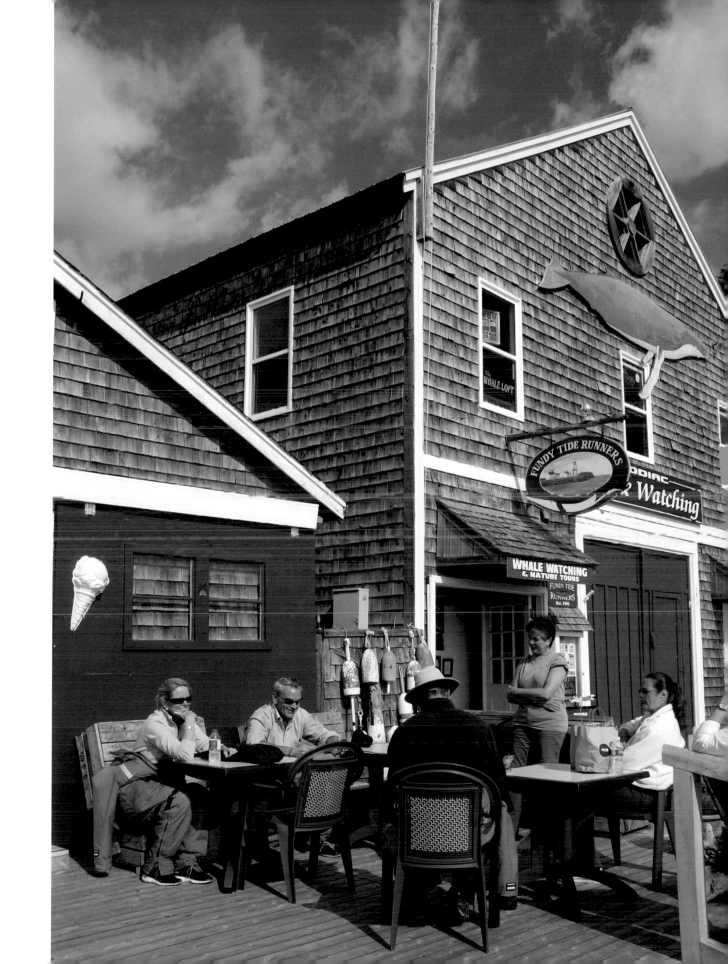

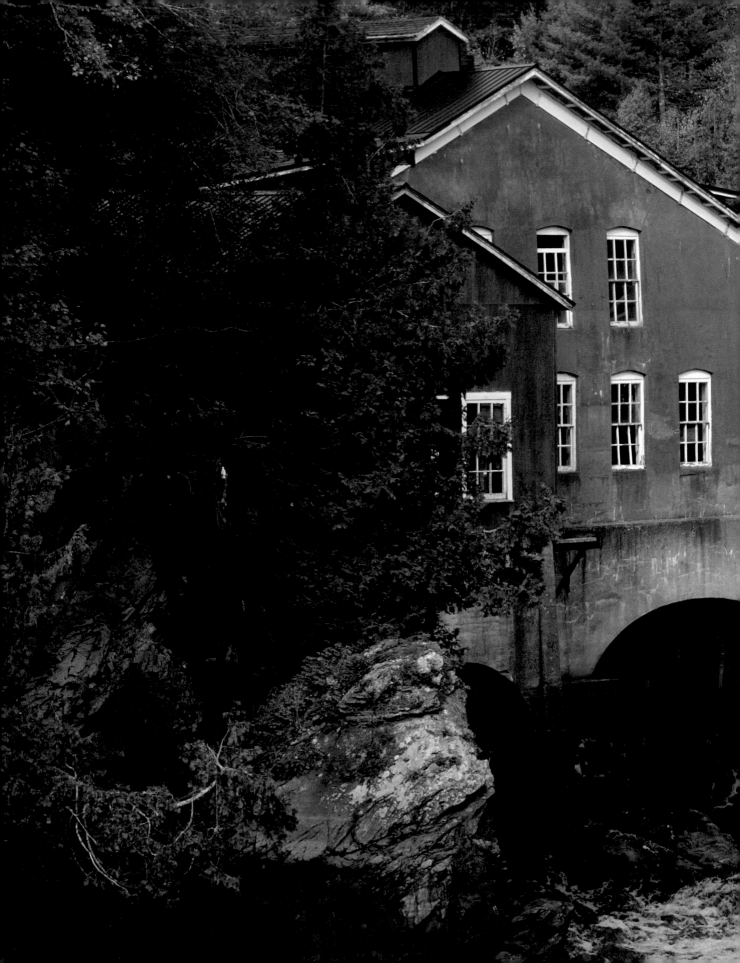

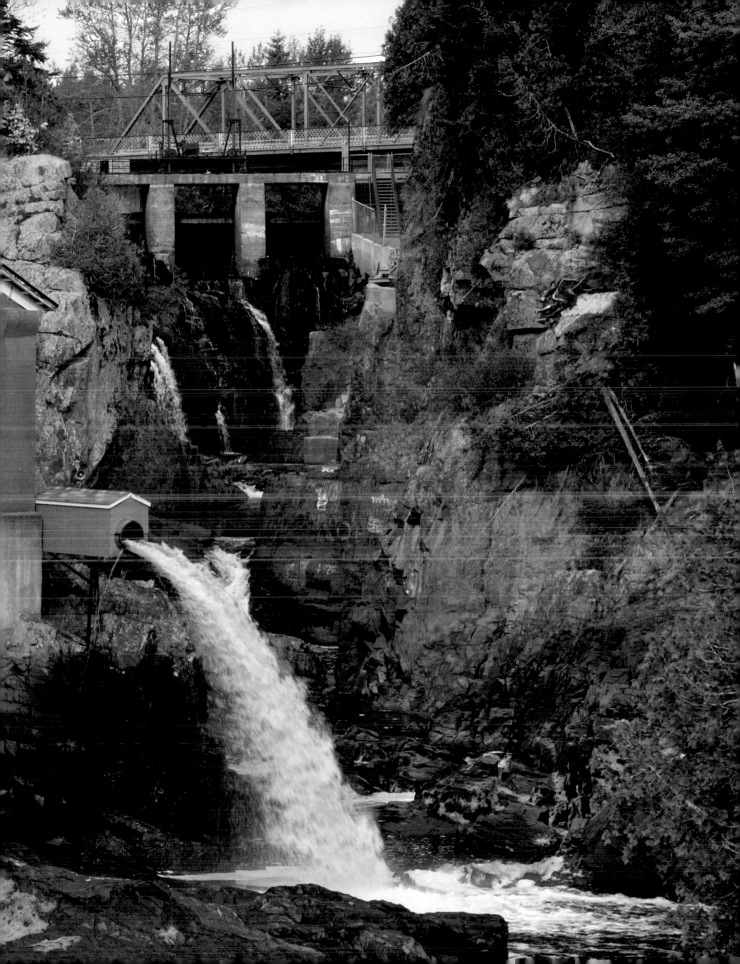

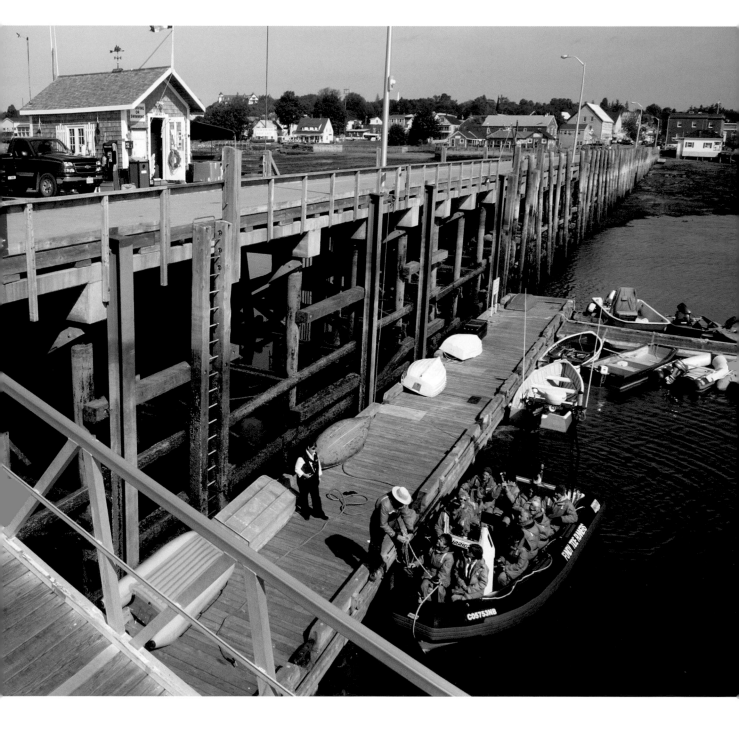

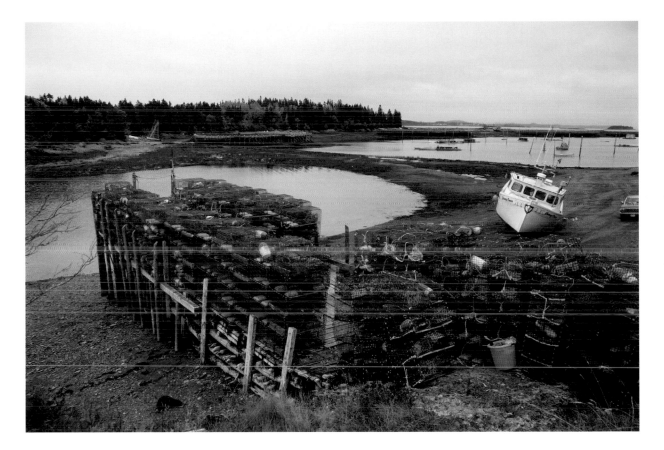

ABOVE: Lower Cove of Leonardville Harbour, with its lobster traps, small lobster pound, and boats, creates a quaint maritime atmosphere in this little spot on Deer Island.

FACING PAGE: At the end of the St. Andrews pier, enthusiasts climb into the Fundy Tide Runners' zodiac for an exciting whale-watching trip in Passamaquoddy Bay.

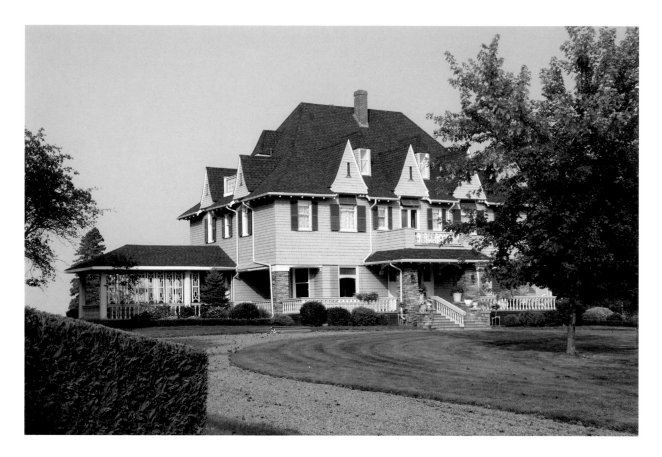

ABOVE: The Hillcrest house and its furniture and gardens were designed by Edward Maxwell of Montreal. The house was built for Charles Randolph Hosmer, an employee of CPR and owner of Ogilvie Flour Mills Company.

FACING PAGE: The Carpenter Gothic style United Baptist Church (1865) emanates majesty with its tall, narrow wooden spires.

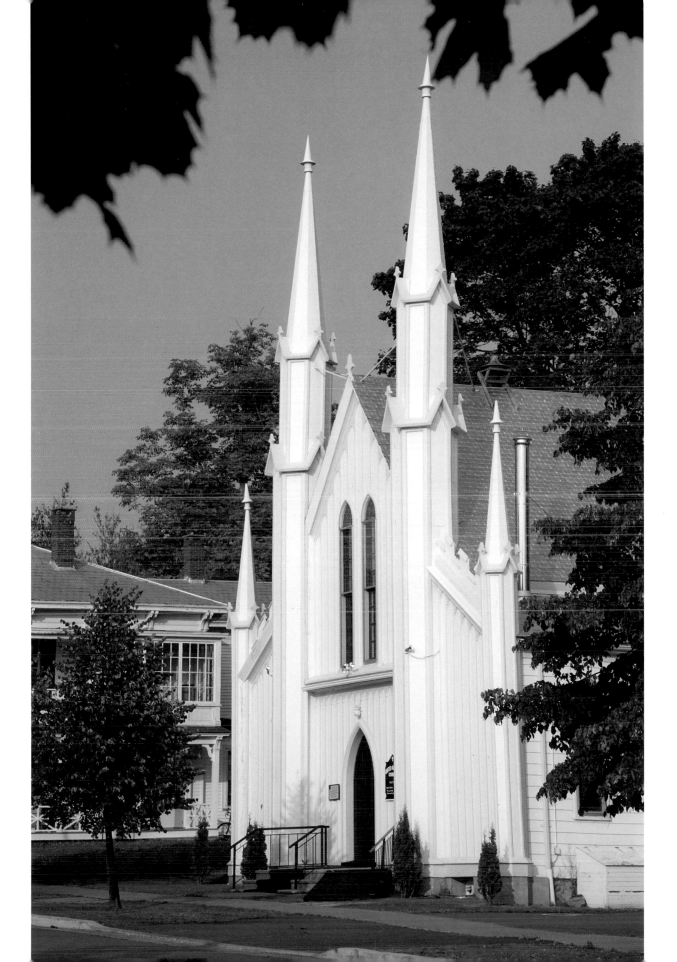

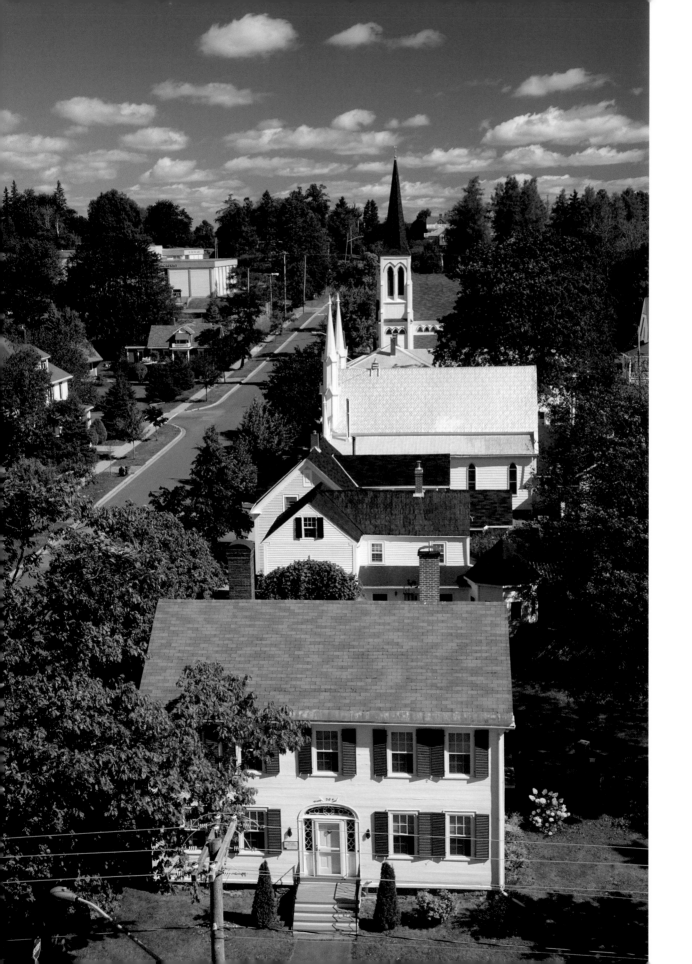

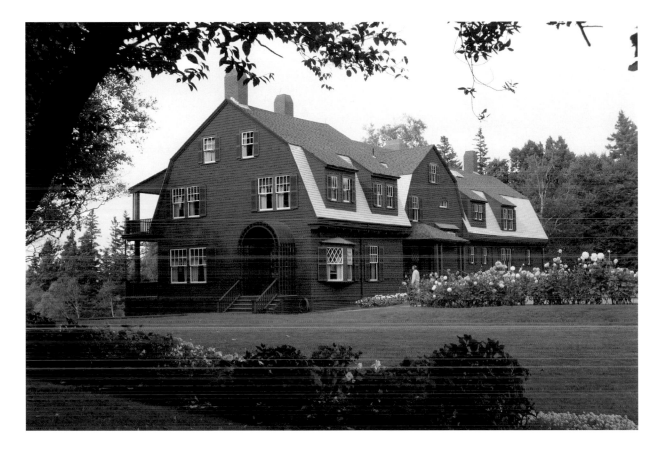

ABOVE: Franklin D. Roosevelt's thirty-four-room summer cottage is one of a few lavish cottages built on Campobello Island around the 1880s when the island was being advertised in Canada and the United States as a summer resort location.

FACING PAGE: A view from the bell tower of All Saints Church looking up King Street shows a Georgian style house with shiplap siding, the United Baptist Church, and the Church of St. Andrew.

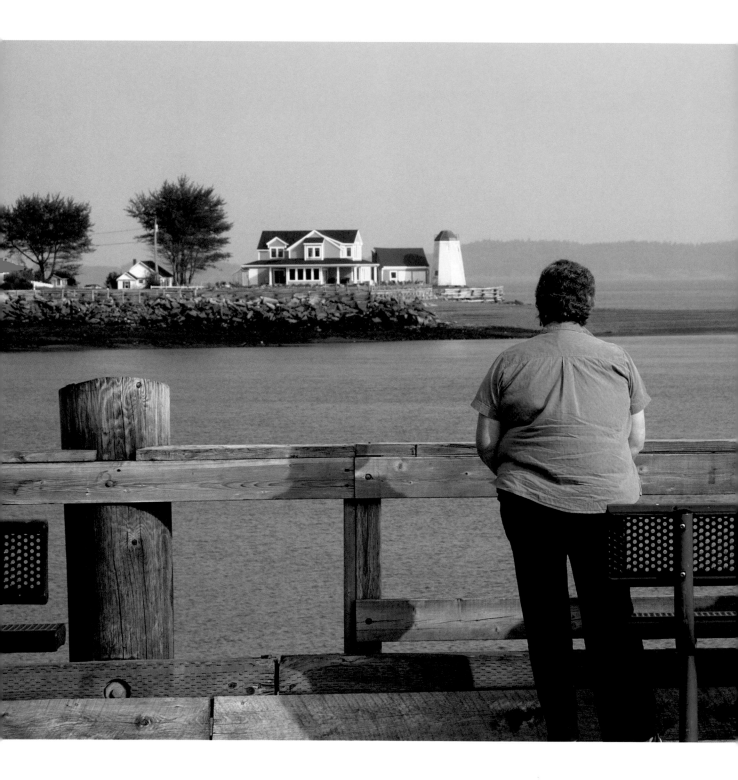

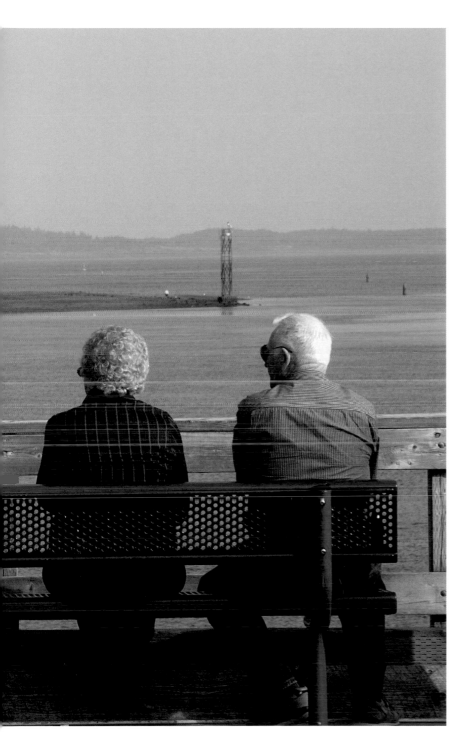

*From the end of the town's pier the
1833 Pendlebury Lighthouse juts
out into the mouth of the harbour.*

An aerial view of the world's largest lobster pound, Paturel International in Northern Harbour. Lobsters are shipped from all over the Maritimes and stored, if necessary, in either tanks or the tidal pound before being sent to various world markets.

OVERLEAF LEFT: Among the many striking features of Greenock Church are the ten bird's eye maple columns, the 1912 pipe organ, and the Scottish thistles in the four corners of the ceiling.

OVERLEAF RIGHT: The spire of Greenock Church (1824), which was one of New Brunswick's most expensive churches in its day, features an octagonal belfry, clock, and sculpted oak tree.

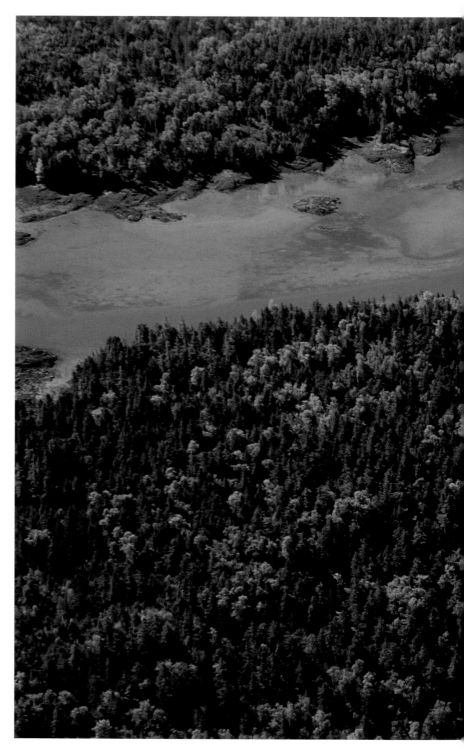

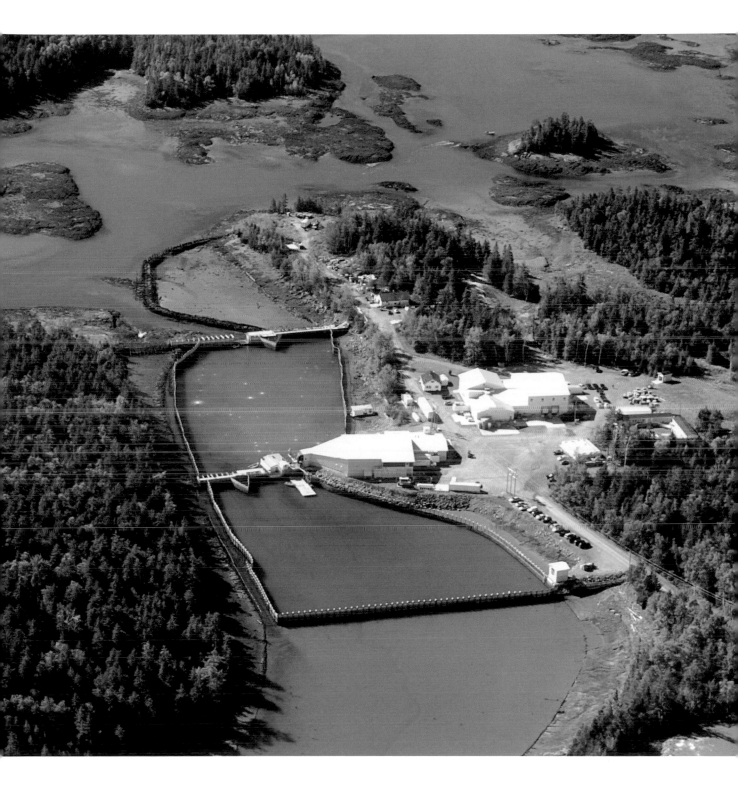

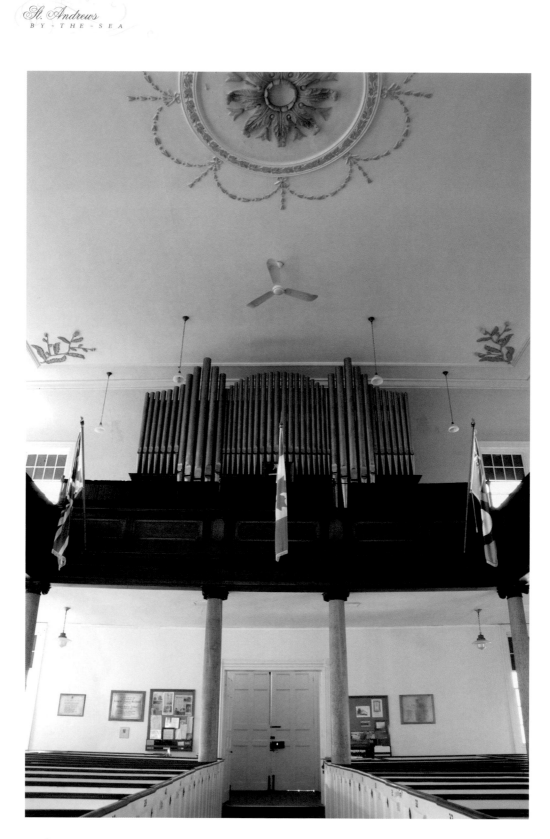

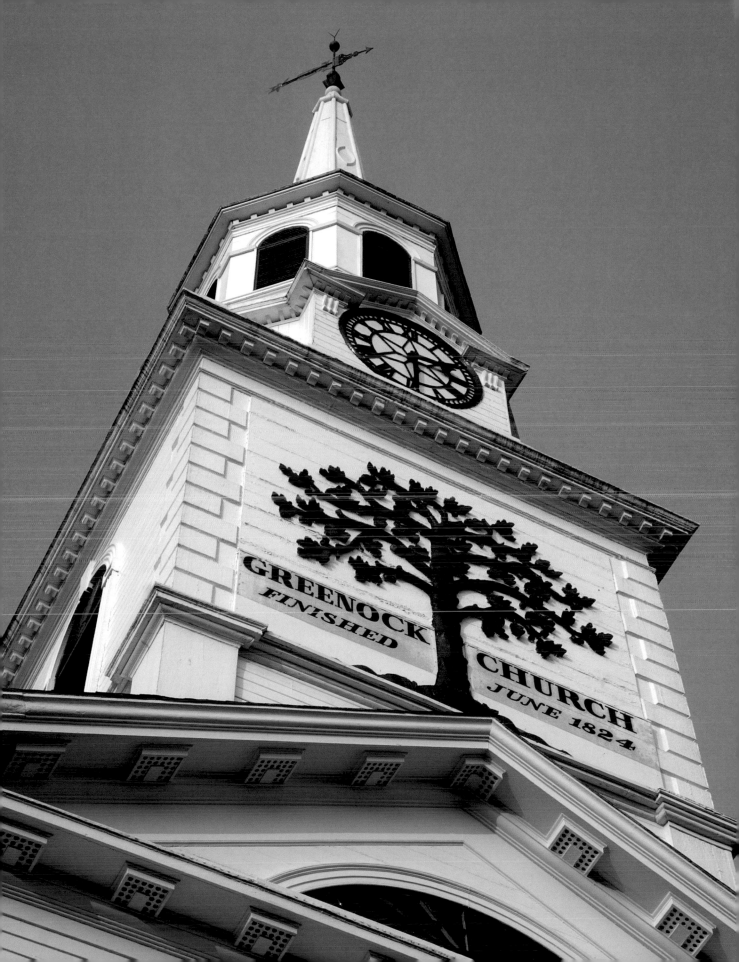

GREENOCK FINISHED CHURCH JUNE 1824

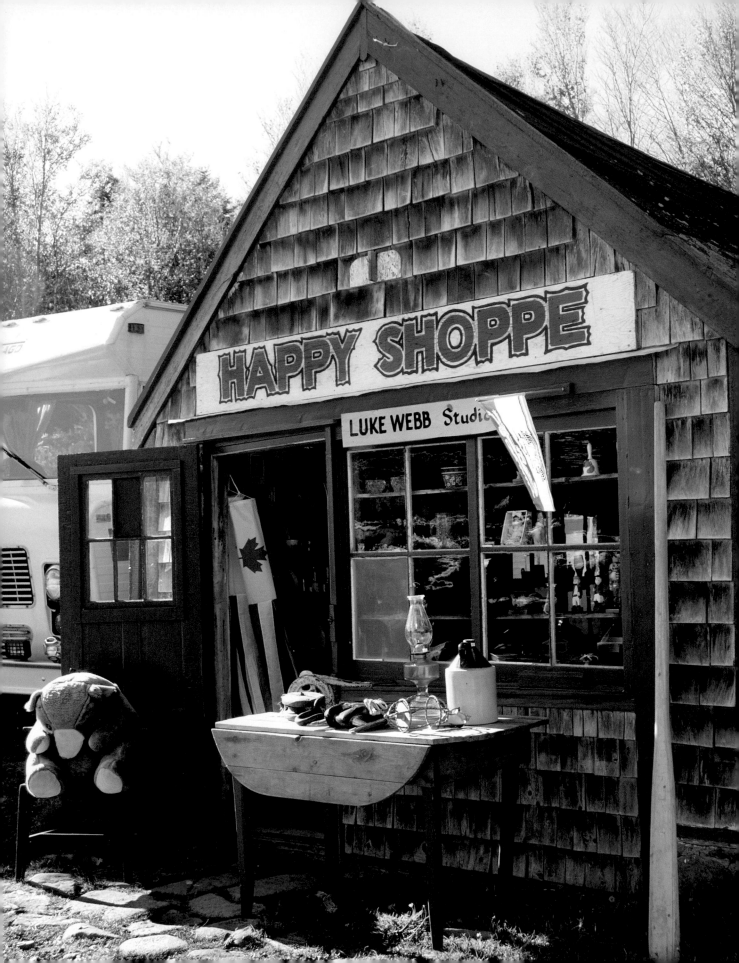

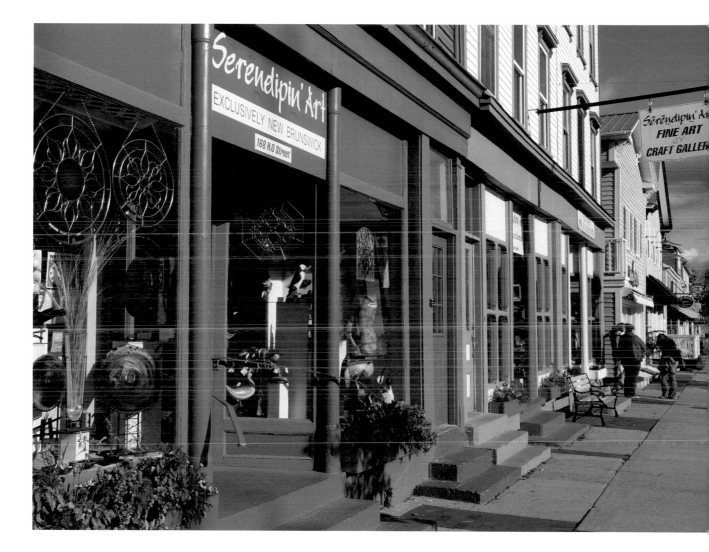

ABOVE: Serendipin' Art is one of several arts and crafts stores in the downtown area that proudly showcases both local and New Brunswick artists.

FACING PAGE: The tiny Happy Shoppe of Deer Island contains shelves and shelves of used books and antiques.

A small, cozy maritime cottage looks over Leonardville Harbour of Deer Island.